IMAGES *of America*

STONE MOUNTAIN PARK

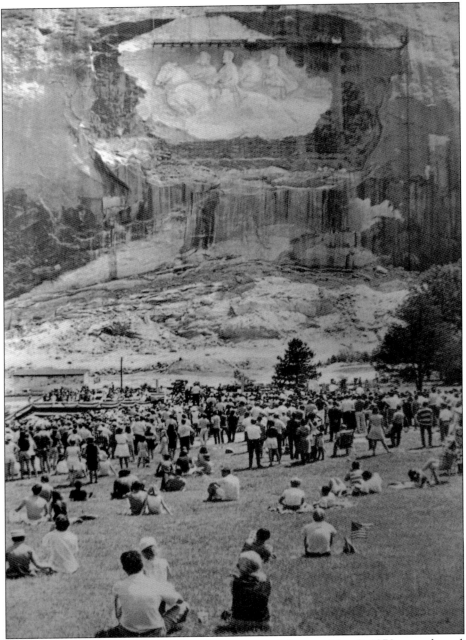

It had taken 55 years since the idea was first suggested, but on May 9, 1970, crowds gathered at Stone Mountain Park for the dedication of the giant Confederate Memorial carving on the mountain's north face. (Stone Mountain collection.)

ON THE COVER: One of the features added after the State of Georgia took over the operation of Stone Mountain Park in 1958 was the paddle-wheel showboat the *Robert E. Lee*, seen here making its way across the newly created Stone Mountain Lake. (Linda Whittington collection.)

IMAGES of America
STONE MOUNTAIN PARK

Tim Hollis

Copyright © 2009 by Tim Hollis
ISBN 978-0-7385-6823-2

Published by Arcadia Publishing
Charleston, South Carolina

Printed in the United States of America

Library of Congress Control Number: 2008942743

For all general information contact Arcadia Publishing at:
Telephone 843-853-2070
Fax 843-853-0044
E-mail sales@arcadiapublishing.com
For customer service and orders:
Toll-Free 1-888-313-2665

Visit us on the Internet at www.arcadiapublishing.com

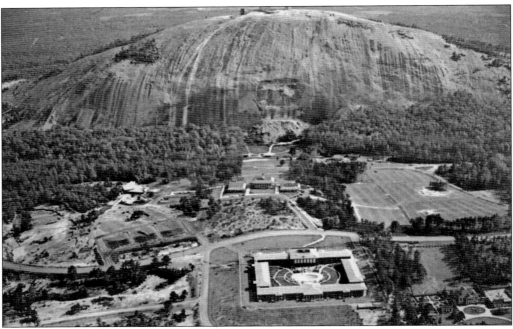

The State of Georgia had acquired Stone Mountain and its surrounding property in 1958 and, by the time of this mid-1960s aerial view, had turned the area into a park with a variety of attractions for young and old. (Author's collection.)

Contents

Introduction		7
1.	How to Carve a Mountain—or Not	9
2.	The State Steps In	31
3.	The South Rises Again	59
4.	Taking the Mountain Home with You	93
5.	Stone Mountain at the Crossroads of Life	115

INTRODUCTION

Although there would seem to be a gap the size of a couple of oceans between the approaches of two of Georgia's primary tourist attractions—Stone Mountain Park and Six Flags Over Georgia—the fact is that this book about the former came about because of the latter.

Those of you who have followed my past excursions through the world of Southern tourism history will recall that somewhere along the way I was responsible for Six Flags' 40th anniversary book. At the time, I was doing quite a bit of work with Stone Mountain as well, helping coordinate some popular museum exhibits of my tourism memorabilia. Needless to say, there exists somewhat of a rivalry between the two tourism titans, and more than once I was asked by Stone Mountain employees why I was not doing a book about them instead of Six Flags. My reply was that I had to do whatever came along, but that I would certainly investigate a Stone Mountain book when I got some other deadlines met.

Well, that time finally came. Working on this book was in some ways the opposite of most of the others I have written. In many cases, I am faced with a seemingly unorganizable pile of photographs and other illustrations, with the task being to find enough historical information to put them into context. In Stone Mountain's case, it took much more work to obtain the photographs than to get the story behind them. It is somewhat ironic that images from the decades before a park was conceived are more readily available—if not always what we think of today as great quality—than the mounds of publicity material that should have been preserved since the State of Georgia took over the property in 1958.

What you are about to see is a drastically simplified version of how the idea for a Confederate Memorial carving on the face of Stone Mountain was conceived and almost did not get executed. For those who want the complete story told detail by detail, I can heartily recommend David B. Freeman's exhaustive history *Carved in Stone*, published by Mercer University Press in 1997 and still available through the park's gift shops. Freeman did more than his share of homework to get the whole lengthy saga in order, and his work was the main source for this one. Freeman chose to devote less space to the more commercial aspects of the park, but this book attempts to put those elements into their proper historical perspective alongside the carving.

To bring to a close the aforementioned connection between this book and the earlier Six Flags one, I should point out that my own experience with both attractions goes back to the same month and year. When my parents and I journeyed to Atlanta in August 1967 to visit the newly opened Six Flags, we took the opportunity to visit Stone Mountain Park as well. My dad was using one of those traditional Polaroid cameras at the time—you remember, the ones where you had to wait after taking the picture and then peel off and discard the sticky paper covering it?—so, for some reason, he did not take many photographs of the park on that first trip. However, for reasons now unknown to me, we returned to Stone Mountain in January 1968, and this time my dad was shooting color slides with his 35-mm camera. The one you see here of a pedantic-looking

five-year-old me is part of that set, and some of the others scattered throughout the book came from that long-ago set of slides as well.

So, that is enough introduction. It is time to let the hands of time carry us all back to the days shortly after the 1800s had become the 1900s and there were still people living who personally remembered the events surrounding the Civil War. Some of those survivors felt there should be some sort of permanent monument to the "lost cause" of the Confederacy. Things did not always turn out just as they had planned, but the fact that Stone Mountain Park is still drawing record numbers of tourists today certainly proves that they were onto something really big—like a huge granite mountain, for example.

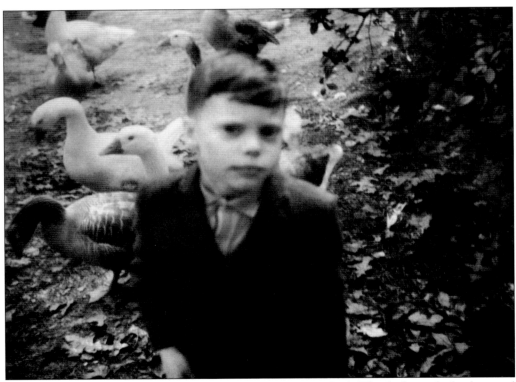

This is the author on a January 1968 visit to Stone Mountain Park. The ducks in the background seem to be totally unimpressed by having a future writer and historian in their midst. (Author's collection.)

One

How to Carve a Mountain—or Not

Inasmuch as Georgia's Stone Mountain, only 16 miles east of Atlanta, is believed to be the largest granite outcropping in North America, it should not be surprising that it has been an object of interest and legend ever since human beings had inhabited its neighborhood. What is slightly more unexplainable is how several different people simultaneously got the idea that its sheer north face should be carved into some sort of monument to the lost cause of the Confederate states.

Historical evidence shows that physician Francis Tichnor had suggested the idea as far back as 1869, but it was in 1914 that attorney William H. Terrell, newspaper editor John Temple Graves, and 85-year-old Helen Plane, honorary life president of the Georgia division of the United Daughters of the Confederacy, all began lobbying for some sort of grand granite Confederate Memorial. At first, their ideas all seemed to center around a giant statue of Gen. Robert E. Lee, but when Plane made contact with famed sculptor Gutzon Borglum, the scope expanded into a scale that only an artist's temperament could conceive.

Borglum's initial idea was to have a continuous procession of Confederate soldiers coming over the top and down the face of Stone Mountain. As he planned it, there would be anywhere from 700 to 1,000 individual figures, and the whole scene would be 1,200 feet long. Artistic dreams soon collided head-on with pragmatism, and the project was eventually whittled down to the three main figures of Lee, Confederate president Jefferson Davis, and Gen. Stonewall Jackson—with other marchers to be added behind them as time and money permitted. A ceremony was held on May 20, 1916, to mark the official start of the project.

You know what they say about the best-laid plans going oft awry, and the plans for the Stone Mountain carving were far from being the best laid. Within only a few years, irreconcilable differences had forced Borglum out, and his immediate successor, Augustus Lukeman, began tinkering with what had been accomplished so far. As we are about to see, all of this infighting threatened to turn the memorial into a cause as lost as that of the Confederacy.

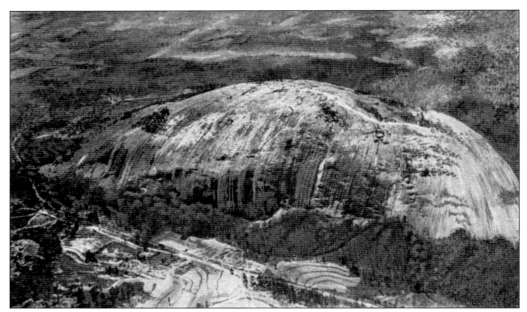

Spanish explorer Juan Pardo may well have been the first non–Native American to see Stone Mountain. In 1567, he described it as a "great gray egg lying half-buried on a vast plain." (Author's collection.)

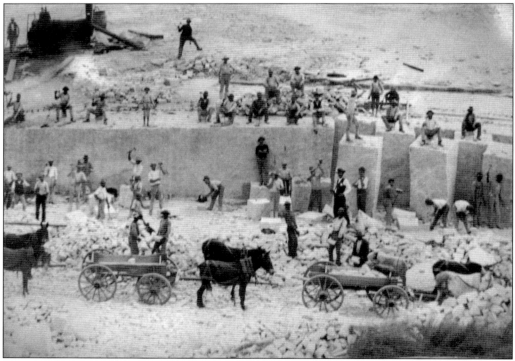

Shortly after the Civil War, granite quarrying became a major industry at Stone Mountain. Chunks of the giant outcropping have been used in countless federal buildings and memorials from coast to coast. (Stone Mountain collection.)

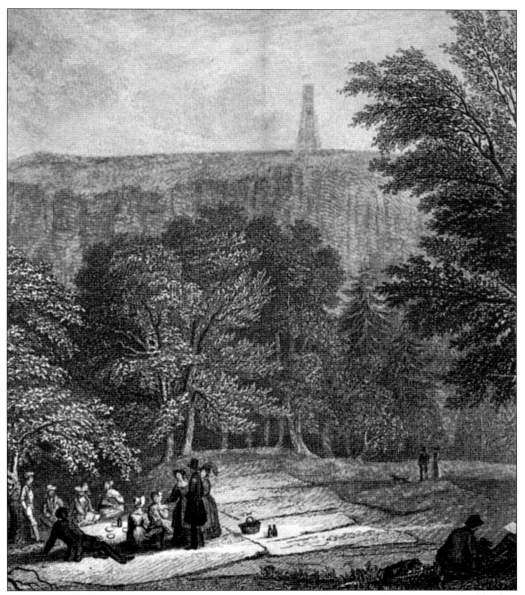

The first tourism development at Stone Mountain occurred in 1838 when Aaron Cloud built a 165-foot observation tower at the summit. Cloud's Tower, as it was known, was a popular spot for locals to visit. Unfortunately the wooden structure was not anchored to anything, and it blew down during a storm in 1849. (Stone Mountain collection.)

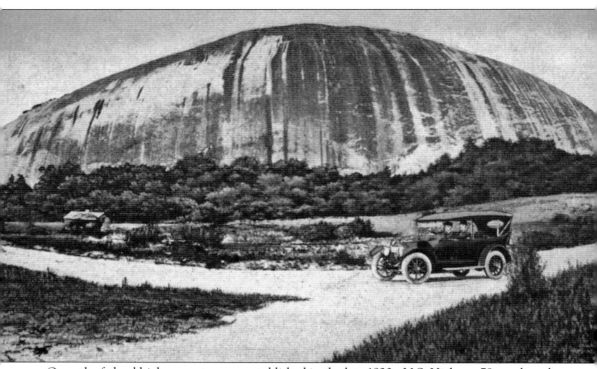

Once the federal highway system was established in the late 1920s, U.S. Highway 78 ran directly past the base of Stone Mountain. This would prove to be a great boon for bringing automobile tourism to the site but posed its own set of problems when the property was to be turned into a state park. (Stone Mountain collection.)

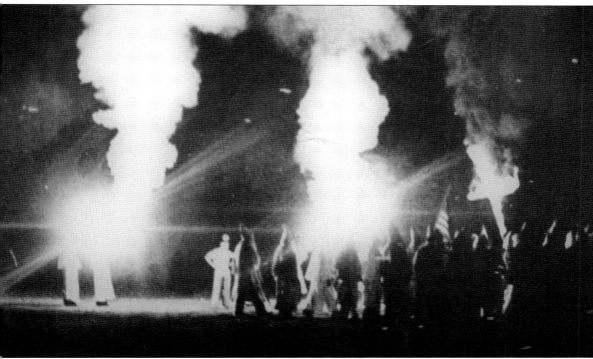

In 1915, as part of the Southern response to D. W. Griffith's pioneering film *Birth of a Nation*, the Ku Klux Klan was revived and used Stone Mountain as its "sacred ground." When a monument to the heroes of the Confederacy was proposed to be carved into the side of the mountain, it resulted in the erroneous—but understandable—impression that the carving itself was a Klan project. (Stone Mountain collection.)

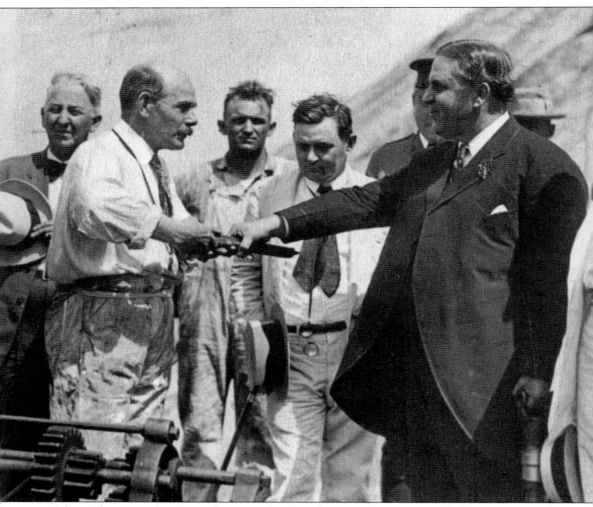

After eight years of trying to figure out just how he was going to accomplish a carving on the sheer side of a granite mountain, on June 18, 1923, sculptor Gutzon Borglum (left) accepted a ceremonial drill bit from Gov. Lee Trinkle of Virginia (right) in an elaborate ceremony. Since Gen. Robert E. Lee, a Virginia native, was the first figure scheduled to be carved, that state perhaps received more attention that day than Stone Mountain's home state of Georgia. (Stone Mountain collection.)

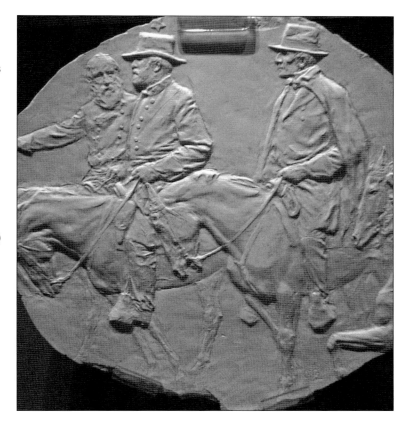

This plaster model, now on display in Stone Mountain's Memorial Hall, shows one of Borglum's original concepts for his carving. Note that his version of Jefferson Davis sported a Santa Claus beard and was depicted looking at General Lee and gesturing with his right arm. (Stone Mountain collection.)

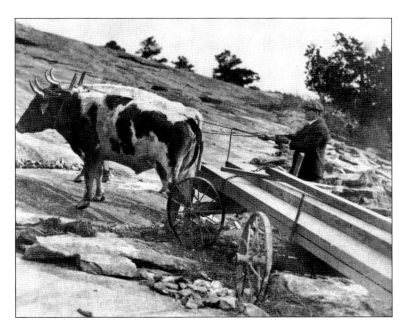

Since the carvers who were going to work on the sculpture had to have somewhere to stand, lumber was hauled to the top of the mountain by oxen and then lowered down the side to build a stairway and platform. (Stone Mountain collection.)

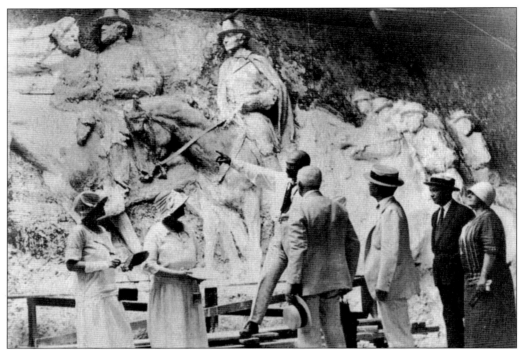

In these two photographs, Borglum is seen explaining one of his models to members of the Stone Mountain Memorial Association. At this point, he was still concentrating primarily on the three main figures, although some of the soldiers trailing them are roughed out here. The horse was Borglum's own steed, which he used as the living model for Lee's horse, Traveler. (Both Stone Mountain collection.)

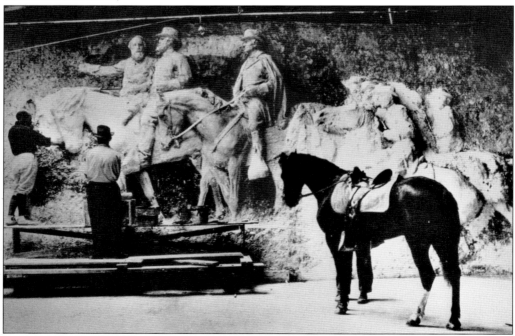

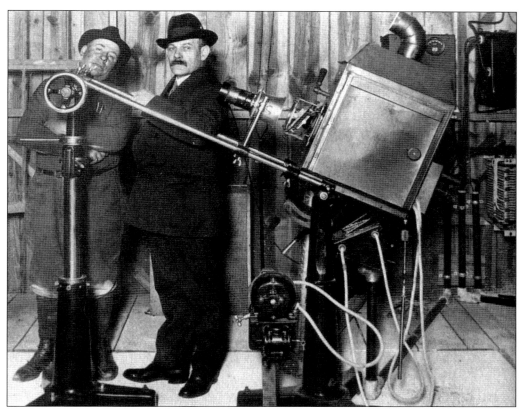

Borglum devised an ingenious way to transfer the outline of his planned figures to the surface where they were to be carved. He had this slide projector specially built to shine the design onto the mountainside, where it could then be traced onto the rock surface. (Stone Mountain collection.)

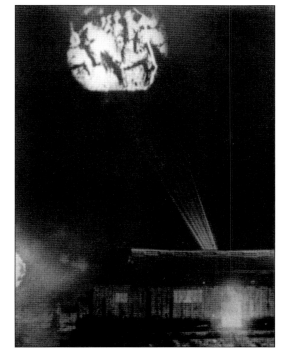

This is supposedly how it looked while Borglum's slide was being projected onto the side of Stone Mountain. It is possible, however, that this is an artist's concept of the scene since the status of nighttime photography at that time would have made capturing such a view difficult. (Stone Mountain collection.)

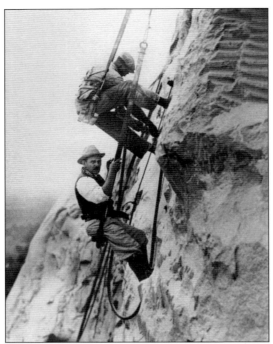

Never let it be said that Borglum (bottom) did not take a hands-on approach to the Stone Mountain carving. Unlike his successors, who did most of their work in their ground-level studio, he had no qualms about dangling from the mountain along with his crew. (Stone Mountain collection.)

This rather blurry image is nevertheless the best available view of Borglum with the full-size model of General Lee's head. (Stone Mountain collection.)

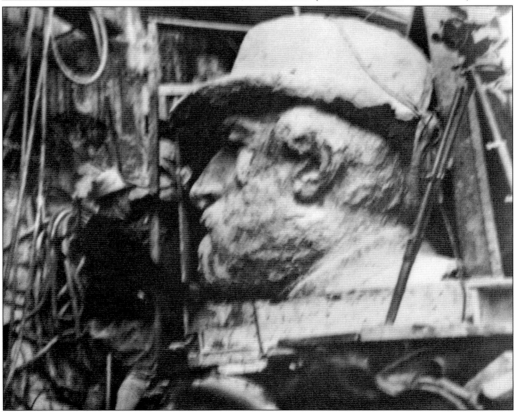

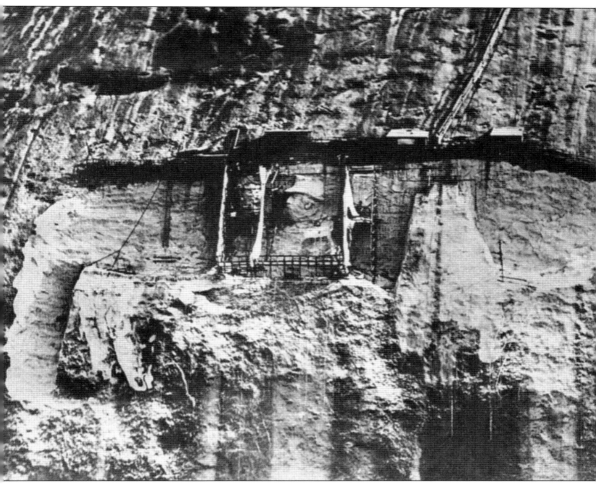

On January 19, 1924, a ceremony was held to mark the unveiling of Borglum's head of Lee. A giant American flag was pulled aside to reveal the general's completed cranium. The rough outline of Lee's horse is barely visible here, as is the preliminary work on Jefferson Davis's bearded visage. (Stone Mountain collection.)

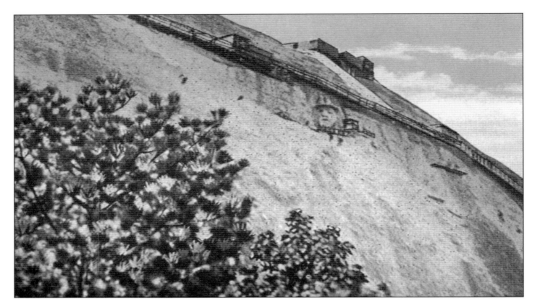

Although the Lee head was much admired, in early 1925 Borglum's differences of opinion with the memorial association (mainly over money, what else?) resulted in his leaving the project and going to Mount Rushmore, South Dakota, to begin a new carving there. (Stone Mountain collection.)

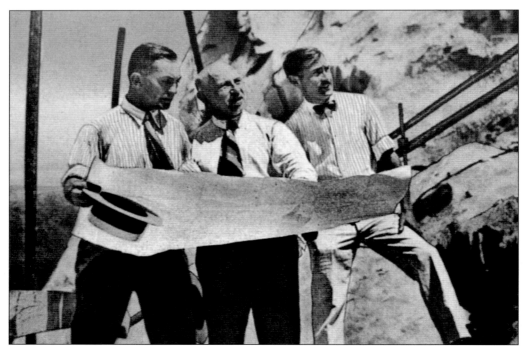

In April 1925, New York sculptor Augustus Lukeman (center) was chosen to take over the work on the Stone Mountain carving. Here he is seen studying the plans and trying to decide how much, if any, of Borglum's work he would be allowed to use. (Stone Mountain collection.)

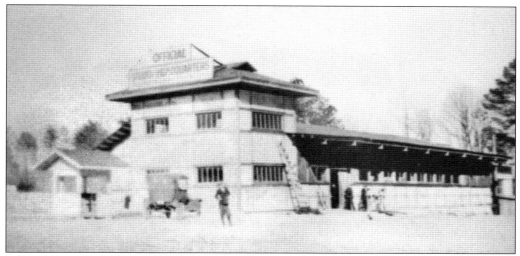

Lukeman's studio at the base of the mountain became something of an attraction in itself because it was the only way curious visitors could get an idea of what was going on hundreds of feet above their heads. (Stone Mountain collection.)

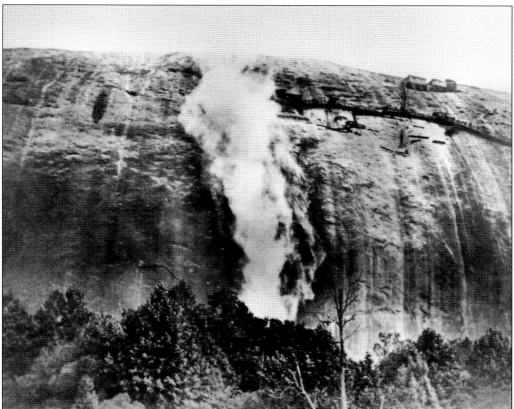

After taking over the project, one of Lukeman's first jobs was to blast a new surface area for the carving. His version would be positioned lower on the mountain than the unfinished Borglum carving. (Stone Mountain collection.)

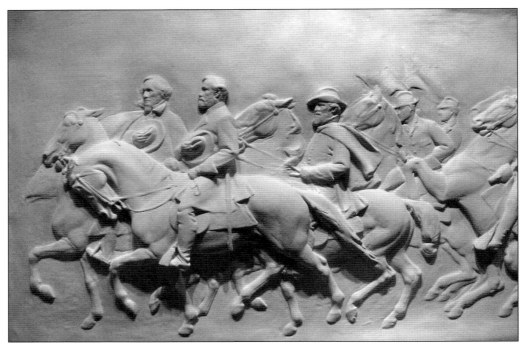

Lukeman's plaster model for the carving shows his major revisions: Lee and Davis are now both looking straight ahead, and Davis looks much more like he did in real life. (Stone Mountain collection.)

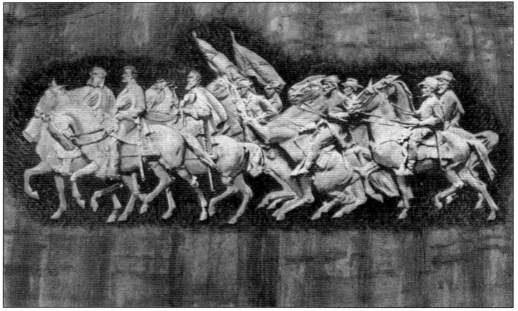

This rendering of the carving reveals why Lee, Davis, and Jackson are all shown holding their hats over their hearts. Originally they were to be saluting the Confederate flags they had just passed . . . but of course, the color bearers never made it from concept art to finished sculpture. (Author's collection.)

Postcard makers of the 1920s produced any number of versions of the carving, which was okay since none of them actually existed in real life. This one chose to show Lee and Traveler alone, somewhat like Helen Plane's original idea. (Author's collection.)

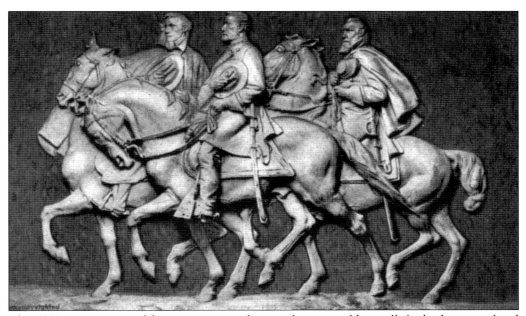

This 1920s anticipation of the carving came closest to how it would actually look when completed almost 50 years later. (Author's collection.)

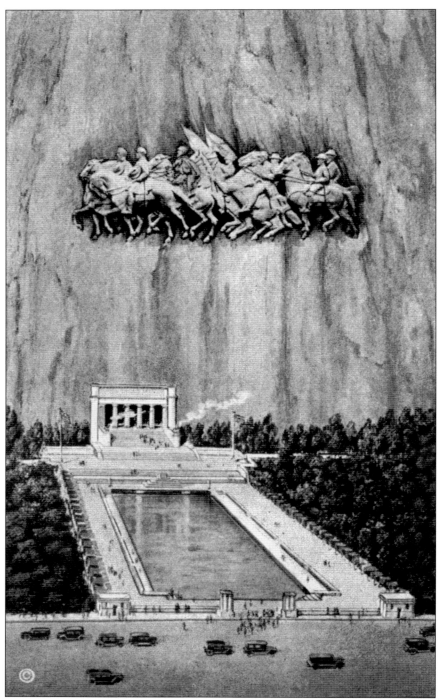

The carving on the mountainside was only one aspect of the grandiose plans for Stone Mountain. As seen in this 1920s rendering, a huge Confederate Memorial Hall was to be carved into the base of the mountain to house the records and documents of the United Daughters of the Confederacy. A long, placid pool would reflect the massive carving above. (Author's collection.)

The Memorial Hall plans were a relic of Borglum's overall concept and continued to be pictured as coming attractions even long after he had departed the project. This huge incense urn was to have graced the long stairway leading to the Memorial Hall's entrance. (Author's collection.)

As Borglum planned it, Memorial Hall would have been 320 feet wide and 60 feet deep into the mountain, and would contain a statue of a Southern woman carved from the surrounding rock. (Author's collection.)

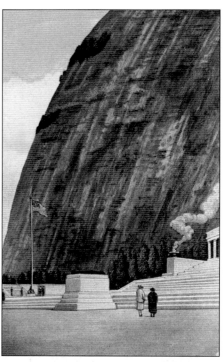

The Confederate Memorial Hall would have deliberately aped the national monuments in Washington, D.C., with its "Tomb of the Unknown Confederate Soldier." (Author's collection.)

Lukeman had completed his version of Lee's head by March 1928. In this photograph, taken shortly before the formal unveiling, notice that Borglum's much larger Lee head was still visible above Lukeman's. Before the unveiling, the Borglum carving would be blasted away so as not to be a distraction. (Stone Mountain collection.)

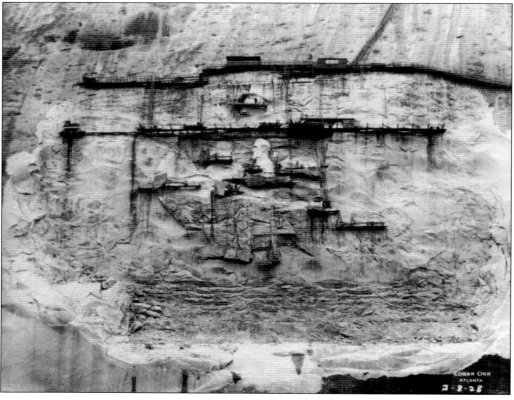

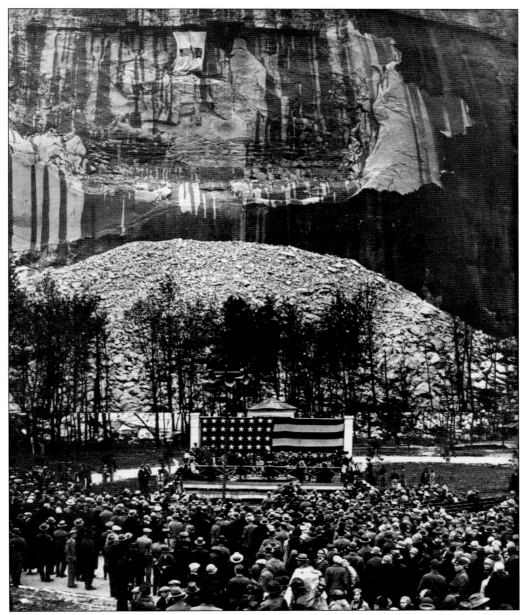

A tarp decorated with the American and Confederate flags covered Lee's head just before its unveiling on April 9, 1928. Reports are that the turnout was somewhat lighter than for the Borglum unveiling four years earlier, probably because people had a feeling that they had been through this before. An honored guest was Lee's great-grandson, five-year-old Robert E. Lee IV. (Stone Mountain collection.)

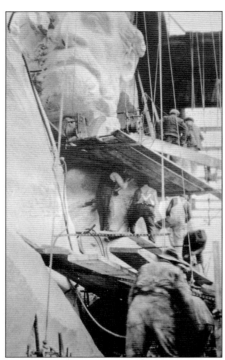

This close-up view shows just how crude the stone carvers' platforms really were. Having finished Lee's head, it appears that they had moved down to work on his torso. (Stone Mountain collection.)

Like Borglum, Lukeman would venture up to the carving when absolutely necessary—just not very often. Here he seems to be giving the carvers some pointers on the finer aspects of Lee's eyeball. (Stone Mountain collection.)

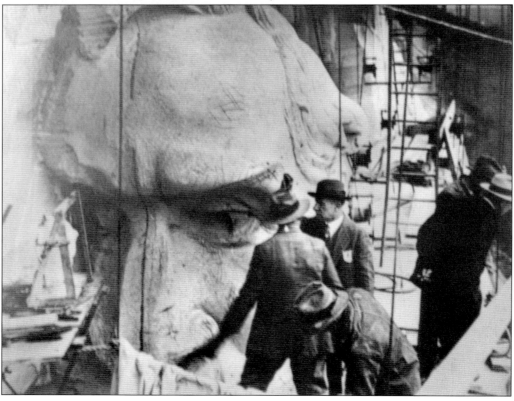

Even from the ground today, it is impossible to conceive just how large the Stone Mountain figures really are. This postcard gives some perspective but is no doubt a heavily retouched composite view. For one thing, none of the platforms or scaffolding are visible, and anyone would have to be out of his mind to go climbing around on the carving itself—especially while wearing a dress suit and hat. This is what might be called 1920s Photoshopping, folks. (Author's collection.)

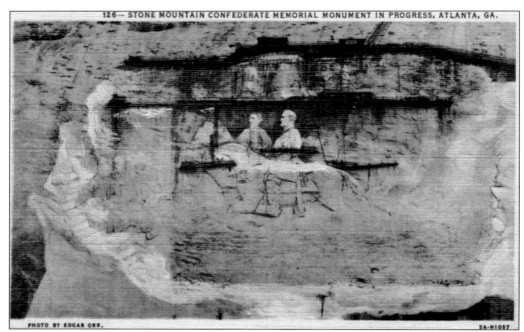

In May 1928, the Stone Mountain Memorial Association's lease on the mountain ran out at about the same time as did the money. This 1935 linen postcard optimistically showed more of Jefferson Davis than actually existed. (Author's collection.)

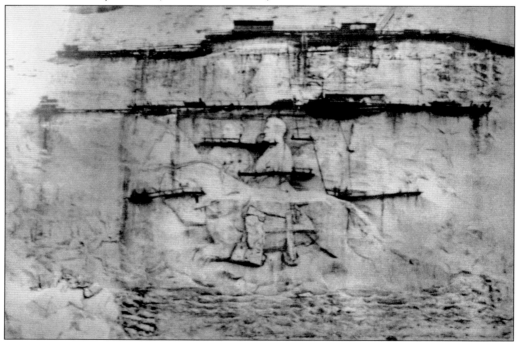

This view of Lee's torso, the outline of his horse, and the bare beginnings of Davis shows how the carving stood from 1928 to 1962. All work had stopped, and the platforms and scaffolding were left to rot in place. (Stone Mountain collection.)

Two

The State Steps In

In the decades after Lukeman's mountain carvers took their tools and went home, there were numerous aborted attempts to reclaim the mountain—which remained private property—and get the memorial back on track. World War II put a temporary kibosh on these efforts, and in the immediate postwar years, the State of Georgia was too busy dealing with school integration and civil rights matters to pay much attention to the continued efforts to get General Lee out of his half-finished quagmire.

Finally, in September 1958, the state managed to get its act together and purchased the dozens of parcels that comprised the mountain and its surrounding property for $1.9 million. One of Georgia's senators could have been speaking for the entire Southern tourism industry, from Virginia to Florida, when he was questioned about the value of the state expending such a huge amount of money for a tourist attraction. "A Yankee tourist is worth a bale of cotton, and twice as easy to pick," he chortled.

For the first two years, the state made only basic improvements, such as picnic areas and restrooms. It seemed everyone had an idea about what the new Stone Mountain State Park should be, including one amusement company that thought of it as an antebellum-themed Disneyland. With the Civil War centennial looming in 1961, everyone realized that something had to be done fast, so work on the new Stone Mountain Lake got underway in late 1960. Other park features in this chapter include the highly promoted Stone Mountain Scenic Railroad (a sort of concession to the Disney-style park idea), the skylift to the top of the mountain, and the observation tower at the summit, which was reminiscent of the early Cloud's Tower development of the 1800s. These attractions were enough to get paying tourists, both Yankee and Southern, through the gates, but they would be joined by a host of others in the years to follow.

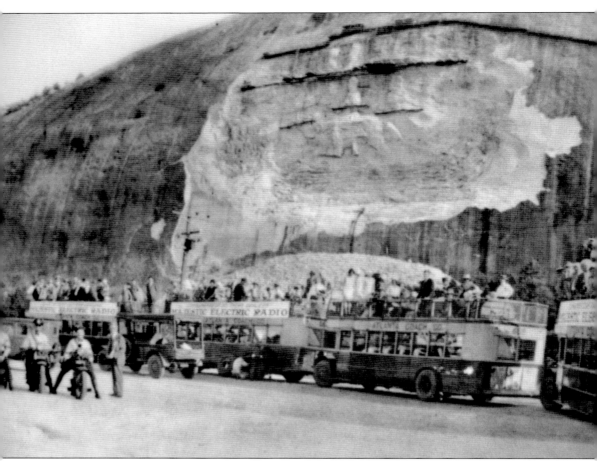

Throughout the 1930s and 1940s, the unfinished and abandoned carving became a legendary attraction all by itself. These sightseeing tour buses brought some of the many visitors who wanted to see the ill-fated project. (Stone Mountain collection.)

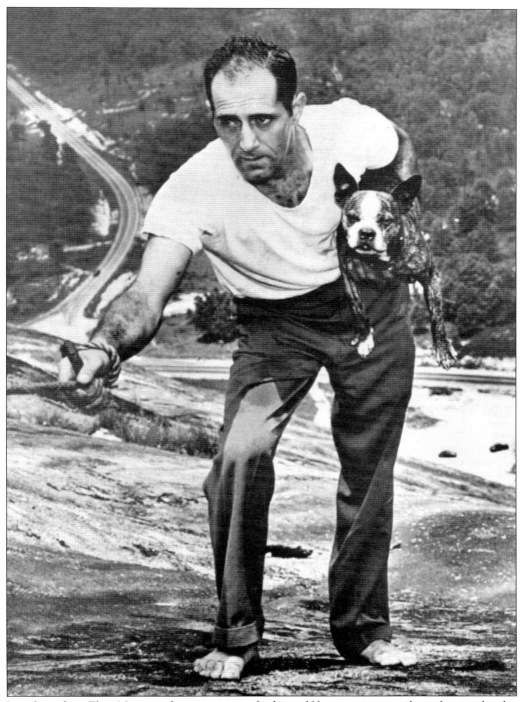
Local resident Elias Nour made a reputation for himself by rescuing people and animals who inadvertently ventured too close to the edge of the mountain and found themselves unable to get back. Note the original route of two-lane U.S. Highway 78 far below Nour's perch. (Stone Mountain collection.)

Even though Stone Mountain was private property from 1928 to 1958, people still managed to climb to the top, and some were reckless enough to try to lower themselves down to the unfinished carving. That is when Elias Nour and his rescue rope came in handy. (Stone Mountain collection.)

Once the State of Georgia purchased Stone Mountain in 1958 and began developing it as a state park, one of the first orders of business was to have U.S. 78 rerouted a mile north. To this day, some portions of the old two-lane highway still exist in the park, such as this stretch that is used by employees only. (Author's collection.)

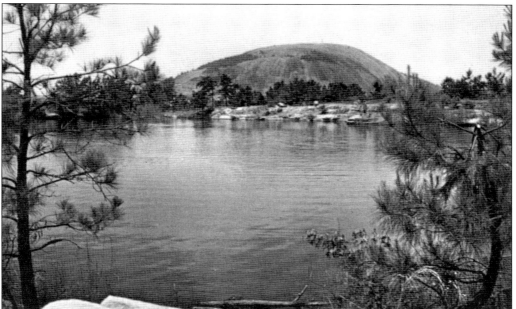

Ground-breaking for the new Stone Mountain Lake was held the last week of 1960. When finished, the lake buried parts of former U.S. 78 under 16 feet of water and would prove to be a centerpiece for much of the park's development to come. (Stone Mountain collection.)

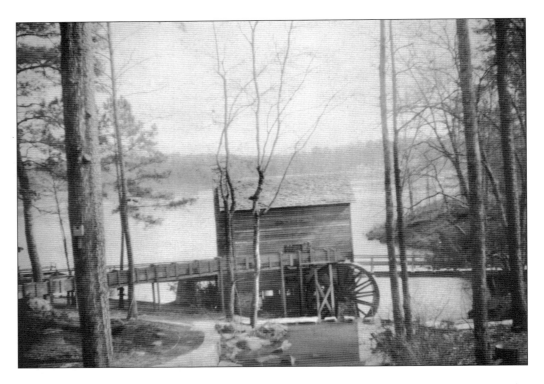

In contrast to some of the attractions that would be added to the park during the 1960s, most of the original features tried to stick with the theme of Georgia's pioneer history. These two views of the restored gristmill are a good example of that early line of reasoning. (Both Author's collection.)

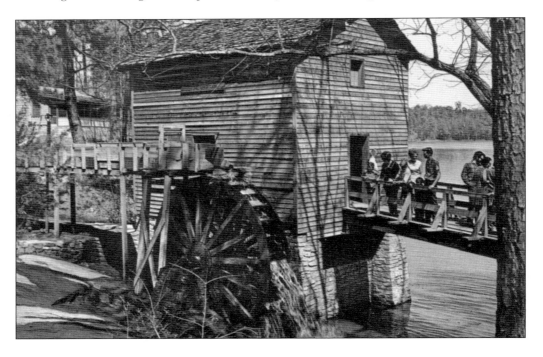

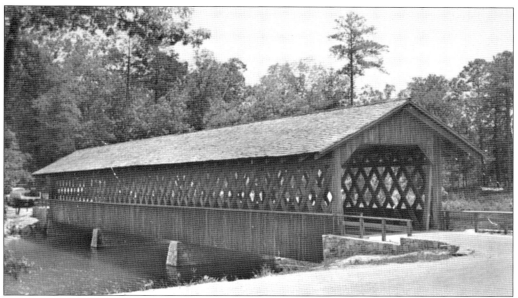

Another history-oriented sight in the park was this covered bridge that was claimed to be more than 100 years old at the time it was installed. It originally spanned the Ocanec River near Athens, Georgia. (Author's collection.)

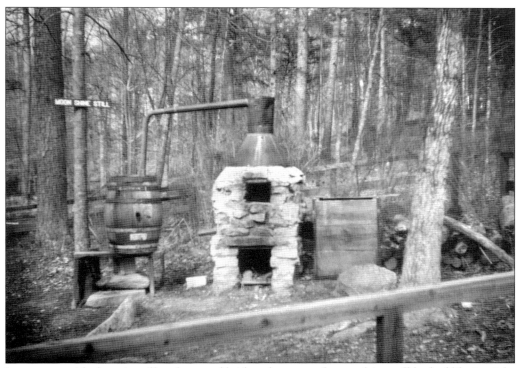

In contrast with the gristmill and covered bridge, the restored moonshine still looked like it might have moseyed down from the Great Smoky Mountains. All it needed was some bewhiskered hillbillies to lounge around it in a drunken stupor. (Author's collection.)

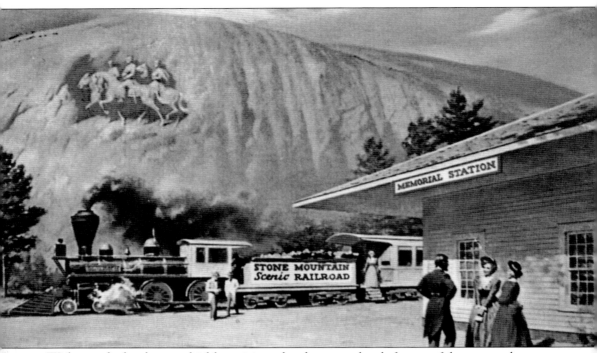

Without a doubt, the most highly anticipated and promoted early feature of the state park era was the Stone Mountain Scenic Railroad. This beautiful piece of concept art was used in advertising for many years, even though it only presumed that the memorial carving would someday be completed. There will be other variations of this painting to come. (Stone Mountain collection.)

In the late 1950s and early 1960s, almost any theme park had to have a railroad encircling it—a la Disneyland—and this was no doubt the thinking process that led to Stone Mountain's railroad. Almost 50 years later, a park employee found this rusting metal sign thrown into a dumpster and rescued it for historic preservation. (Linda Whittington collection.)

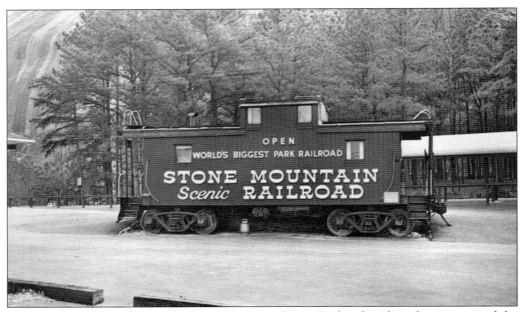

After much advance publicity, the Stone Mountain Scenic Railroad made its first trip around the base of the mountain in April 1962. This caboose served as a billboard to announce the railroad's arrival. (Author's collection.)

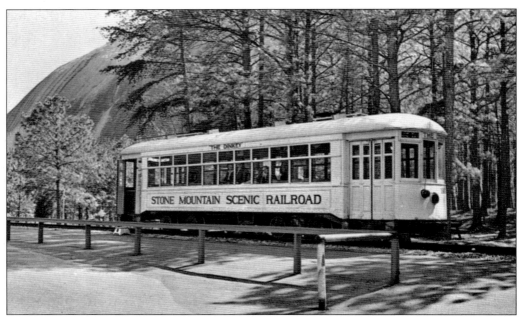

Since the tourism industry was a seasonal business, the normal Stone Mountain Railroad trips took place only from mid-April through Labor Day. During the off-season, this 1910 trolley car, known as the "Dinkey," took smaller crowds of visitors on the same circuitous journey. (Author's collection.)

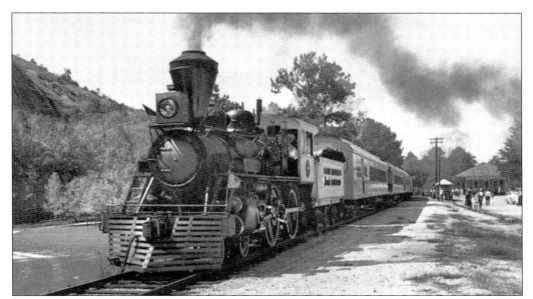

The park's two locomotives, the *General II* and the *Texas II*, were proudly touted as replicas of the two engines that participated in Georgia's famed "Great Locomotive Chase" during the Civil War. (Author's collection.)

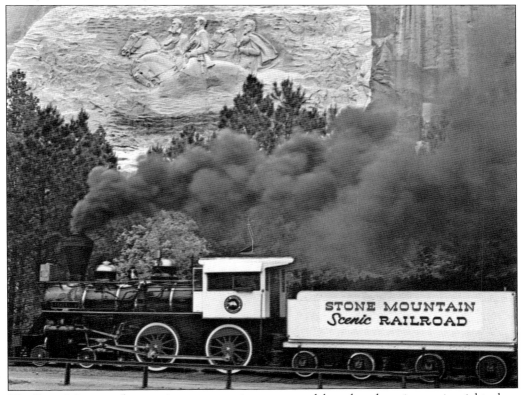

The Stone Mountain locomotives were genuine steam models and made an impressive sight when puffing smoke as they passed the still-unfinished memorial carving. (Author's collection.)

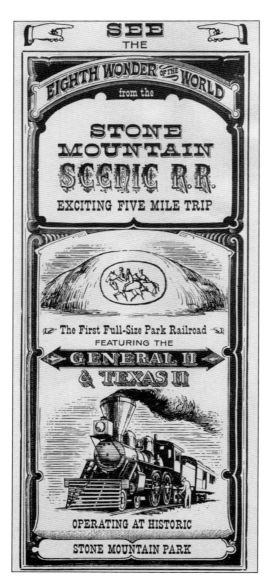

This early brochure charmingly tried to recreate the look of a broadside from the 1800s in its design and lettering. (Author's collection.)

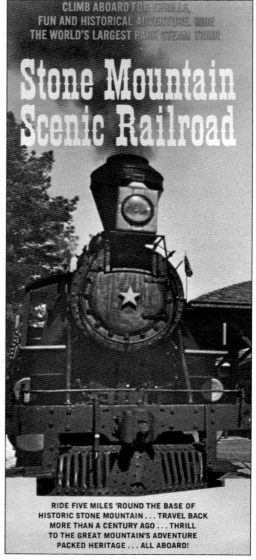

By the time of this c. 1967 brochure, the park had abandoned the 1800s broadside look but still had plenty to promote when it came to the 5-mile round-trip. (Author's collection.)

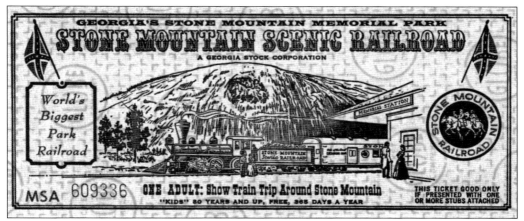

Now where has this artwork been seen before? Oh yes, the Stone Mountain Scenic Railroad tickets incorporated a slightly revised version of the original concept art back on page 38. Note that trips were free for "children" above age 80. (Author's collection.)

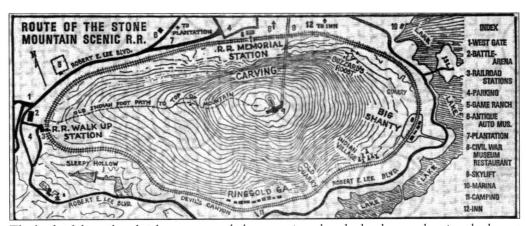

The back of the railroad ticket was a good place to print a handy-dandy map showing the layout of the whole park. It also indicates the locations of the train's two stops, the replica towns of Big Shanty and Ringgold, which were respectively the beginning and ending points of the 1862 "Great Locomotive Chase." (Author's collection.)

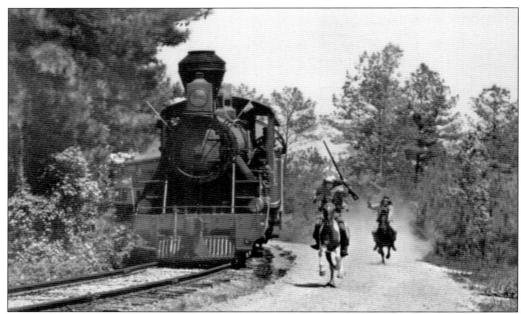

Owing to the popularity of Westerns on television, and probably inspired by such parks as Tweetsie Railroad and Ghost Town in the Sky, the Stone Mountain Scenic Railroad had to endure attacks by hostile Native Americans during every trip. (Author's collection.)

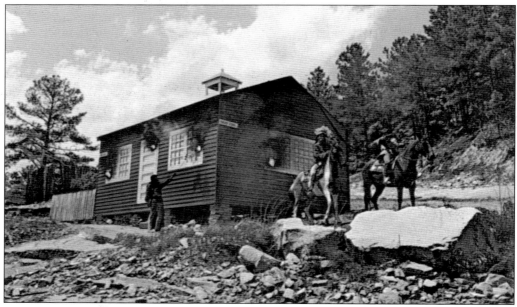

As part of the "exciting five-mile trip," the train would stop at what was purported to be the northwestern Georgia town of Ringgold, where the marauding Native Americans would burn the little red schoolhouse. (Author's collection.)

As this pricelessly corny postcard illustrates, sometimes the regularly scheduled Native American attacks were played for laughs. This brave has just "scalped" a planted visitor wearing the world's most unconvincing bald skullcap, much to the obvious amusement of the other passengers. (Author's collection.)

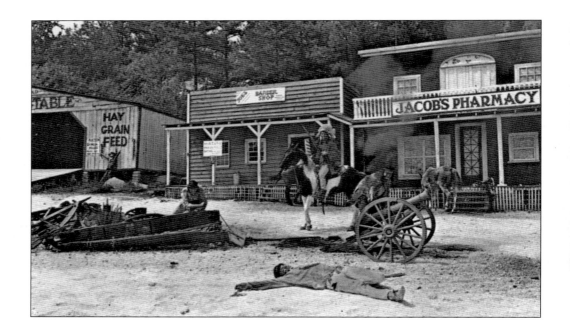

The citizens of the real-life town of Ringgold, Georgia (just past the state line from Chattanooga, Tennessee), could be glad that they did not have to deal with the daily attacks perpetrated on their replica community at Stone Mountain. (Both Author's collection.)

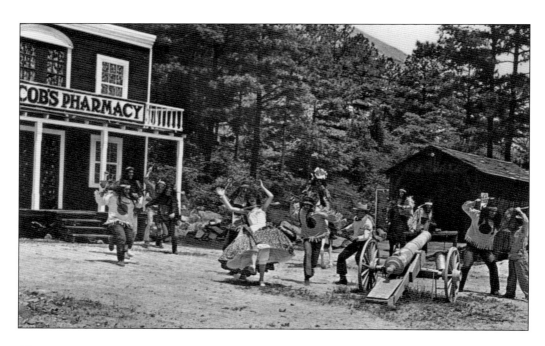

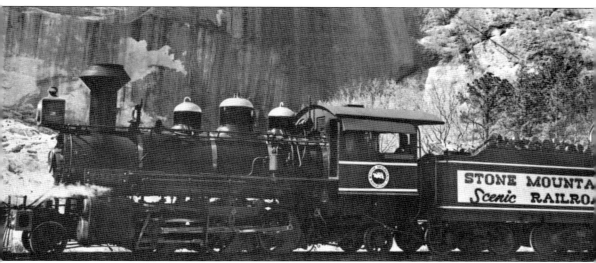

In 1969, Stone Mountain Park added a third locomotive to the Stone Mountain Scenic Railroad. It was named the *Yonah II* in tribute to another engine that took part in 1862's "Great Locomotive Chase." Before receiving its new name, the *Yonah II* had served as a feature of Echo Valley Park near Cleveland, South Carolina. (Author's collection.)

According to David B. Freeman's historical research, a pair of Florida gentlemen, Herbert Fishler and D. C. Land, spent approximately $1 million on their addition to Stone Mountain Park, the skylift ride to the top of the mountain. (Linda Whittington collection.)

Each of the skylift cars could transport 50 visitors at a time, and they traveled much like two buckets in a well: as one car descended the cable, the other would be pulled upward. (Linda Whittington collection.)

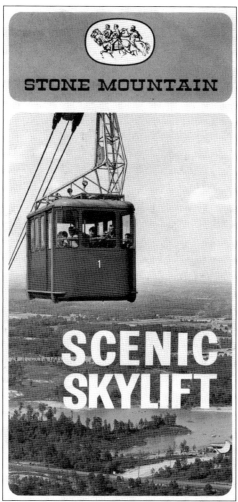

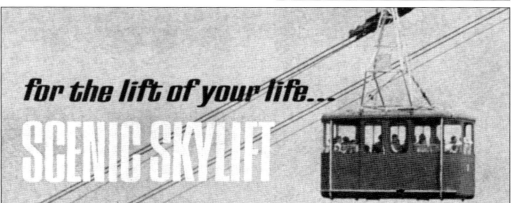

Since the skylift's cable cars were imported from Switzerland, Swiss ambassador August Lindt performed the formal dedication of the new Stone Mountain Park feature in November 1962. (Author's collection.)

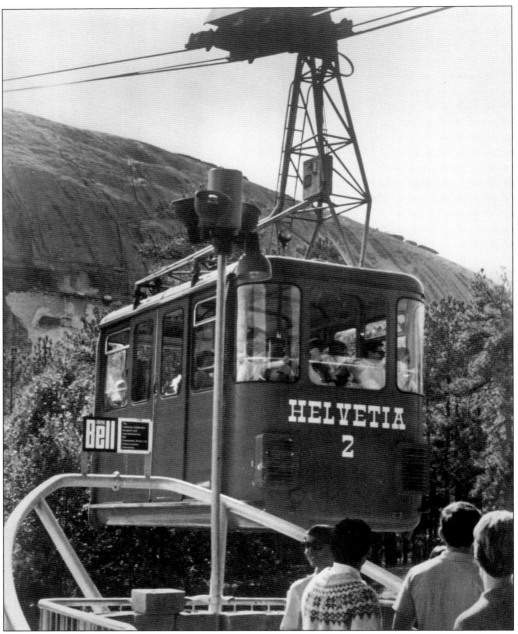
Photographs of the earliest skylift cars are easy to identify because of the cars' rounded corners. Later models had slanted corners, as will be seen later in the book. (Linda Whittington collection.)

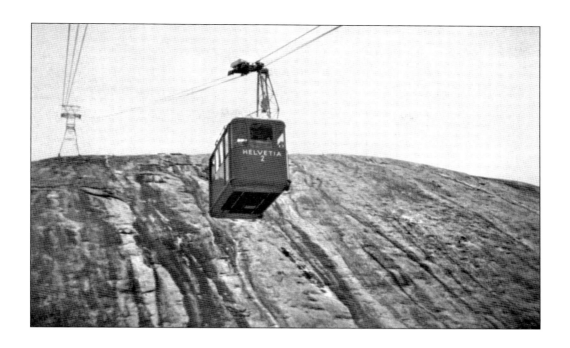

Even today, one of the most exciting parts of a skylift trip up Stone Mountain is when the cable car approaches the metal support tower at the top and lurches forward when it encounters the rollers on which the cable runs. (Both Author's collection.)

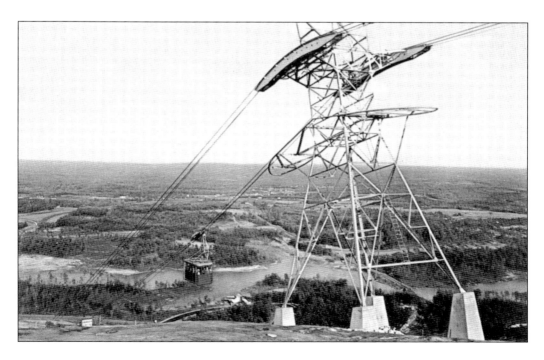

An elaborate building and observation tower were constructed atop Stone Mountain for the benefit of visitors arriving via the skylift. The observation tower was considerably more substantial than the original Cloud's Tower of the 1830s, but it is just as much a part of the past today. (Linda Whittington collection.)

Another feature of the mountaintop was this beautiful reflection pool—strikingly similar to the Borglum design for the Confederate Memorial Hall at the base—where the flags of the Confederate states flew proudly. (Author's collection.)

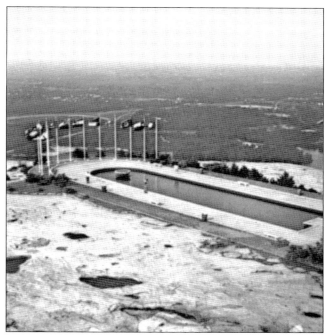

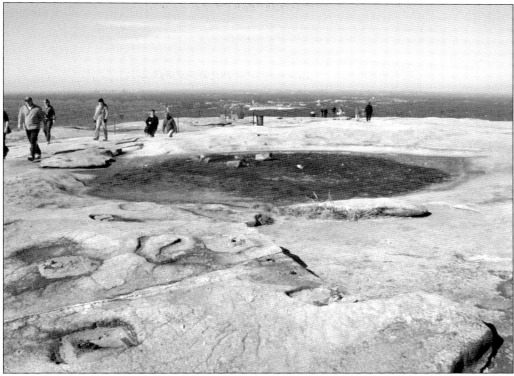

There were big plans to renovate the mountaintop facilities in time for the 1996 Atlanta Olympic Games, but once the observation tower and reflection pool were demolished, nothing new was built to take their place. This is how the pool's former site looks today. (Author's collection.)

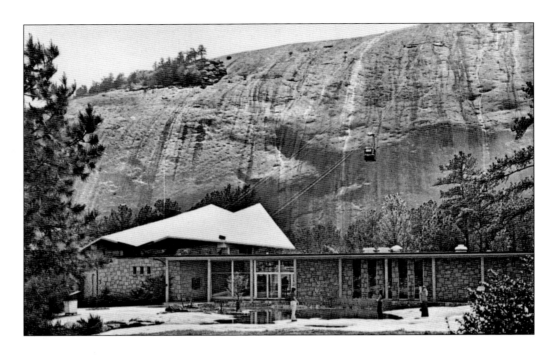

The original entrance building for the skylift sat to the left of the present-day structure. As these two photographs show, it sported a snazzy space-age design that might be considered "Jetsons Moderne." (Both Author's collection.)

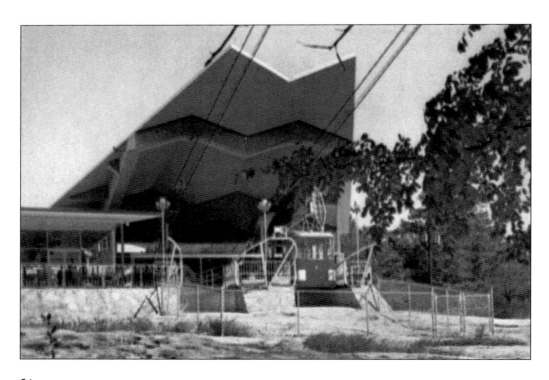

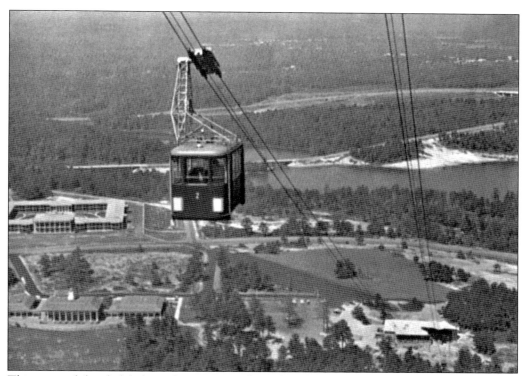

This view of the skylift from the top was taken after the Stone Mountain Inn (rear left) was constructed in 1965. The empty space between Memorial Hall (front left) and the old skylift building (right) is the location for today's skylift departure point. (Author's collection.)

This artwork from a 1960s brochure illustrates the spatial relationships between the skylift, the mountaintop tower and pool, the Stone Mountain Scenic Railroad, Memorial Hall, and the carving. (Author's collection.)

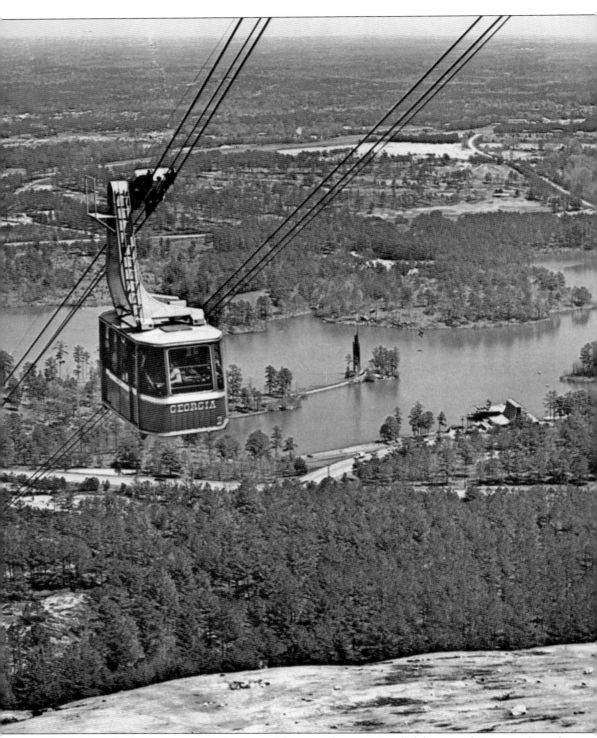

In this breathtaking panoramic view, one of the second-generation skylift cars with its more slanted corners is pictured. It is also easy to see the tell-tale signs where the 450-acre Stone Mountain

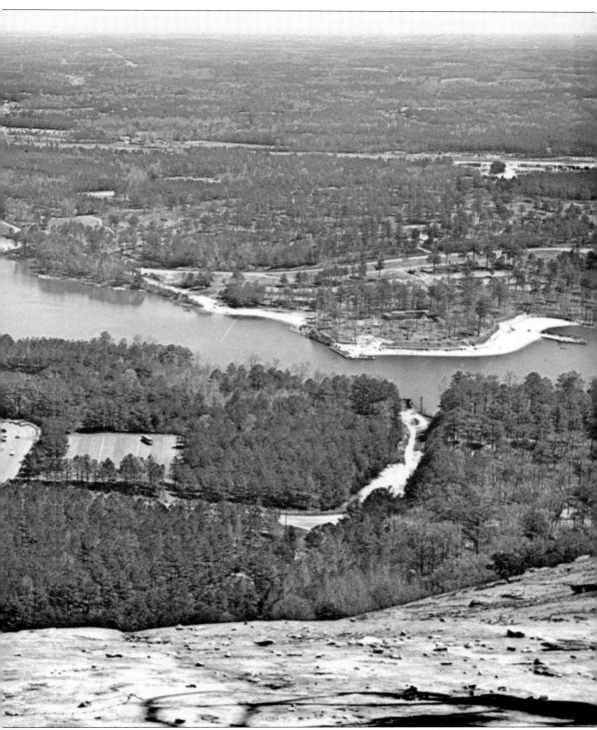

Lake covers part of the original route of U.S. Highway 78. On a clear day, visitors can see all the way to northwest Georgia's Kennesaw Mountain. (Author's collection.)

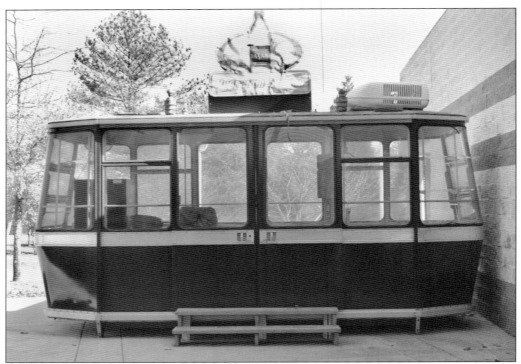

Although new cable cars were installed during the 1996 renovation, one of the slant-corner cars from the early 1970s was preserved and presently serves as a refreshment stand. (Author's collection.)

The old Jetsons-style skylift building, with its wildly projecting roof, also still stands. It is now used as a carpentry shop but is easily visible from the current skylift building next door. (Author's collection.)

Three

THE SOUTH RISES AGAIN

Although Stone Mountain was now officially a Georgia state park, during the 1960s and 1970s, there were many additions that made it seem more like a commercial theme park. Significantly many of these additions were not funded by the state but were the work of concessionaires who leased their spots from the state and set up shop. The Game Ranch, the Antique Auto Museum, the Stone Mountain Inn hotel, and a re-created Southern plantation were among the arrivals of the early 1960s.

With all the Native American attacks, preening Southern belles, Swiss cable cars, and other ballyhoo going on around the base of the mountain, the irritating question remained of what to do with that huge unfinished carving on the side of the monolith. Some people felt that leaving it in its partially completed condition would be a fitting epitaph to the Confederacy's defeat, but others were of the strong opinion that the state should finish what the visionaries of the 1920s had started.

A new sculptor, Walker Hancock, was enlisted to revive Augustus Lukeman's designs and finally get the memorial carving completed. He was also charged with completing an official Confederate Memorial at the mountain's base, an idea that had been a part of the master plan since the Borglum days. Hancock took on both projects, and after much work (and some human lives lost in the process), the carving of Robert E. Lee, Jefferson Davis, and Stonewall Jackson was finally dedicated on May 9, 1970.

Even then, spectators would have noticed that the three Southern heroes were carved only from their horses' stomachs up. With all the time and effort that had been expended for more than 50 years, Hancock and the state officials had finally decided that the extra work involved in carving something as relatively uninteresting as 12 equine legs and six human ones was just not worth it. Artistic license was employed to suggest that the three figures from the past were emerging from the mountain rather than simply being pasted onto it, and visitors have been happy to gaze in awe at such a complex feat—even if there are no feet.

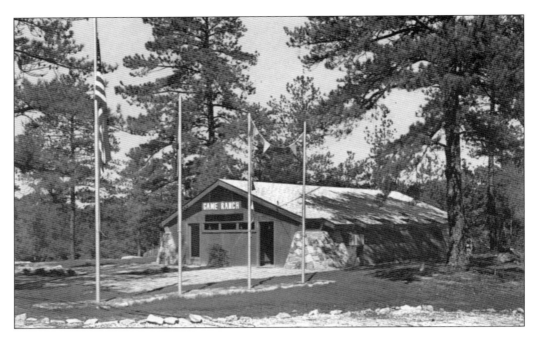

One of Stone Mountain Park's least-publicized attractions was the Game Ranch, operated by G. A. Rilling. It featured assorted wild and tame life and a petting zoo but somehow just never got the same attention as the other park features. It quietly went away in 2001. (Both Author's collection.)

Why do we call Georgia's Stone Mountain A Place for All Seasons?

People... and Nature... and Special Events like:

June 8—Northwest District 4-H Horseshow at the Park's new Covered Arena. Classes begin at 9 a.m.

June 9-10—All Morgan Horse Show at the Covered Arena.

June 18—First in a series of summer Sunday afternoon concerts featuring the Atlanta Symphony Orchestra. At the new covered 7,500 seat field events building. Guest soloist, world-famed guitarist Chet Atkins.

And throughout the year, 3,200 acres of Parkland beckons to come, see and do. That's why we like to call it:

Georgia's Stone Mountain
... A place for All Seasons

How did an advertisement for Florida get into this book? Oh, wait—it is just that by the early 1960s, Stone Mountain Park had learned how to use bikini-clad beach bunnies to advertise the lake and other park features. If it worked for other Southern attractions, why not Stone Mountain? (Author's collection.)

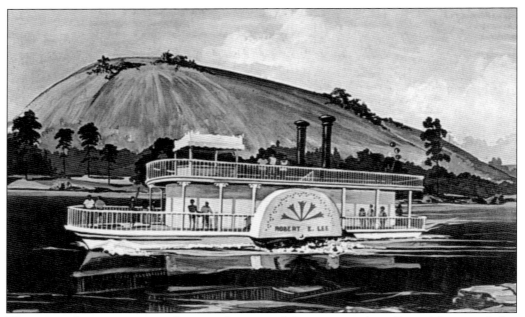
This piece of concept art served to introduce one of the new arrivals on Stone Mountain Lake, the 160-passenger riverboat known as the *Robert E. Lee*. (Author's collection.)

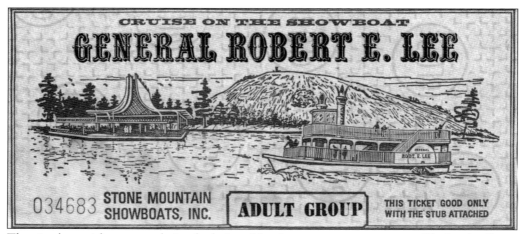
The riverboat tickets were obviously designed by the same company responsible for the Stone Mountain Scenic Railroad ticket seen on page 43. (Author's collection.)

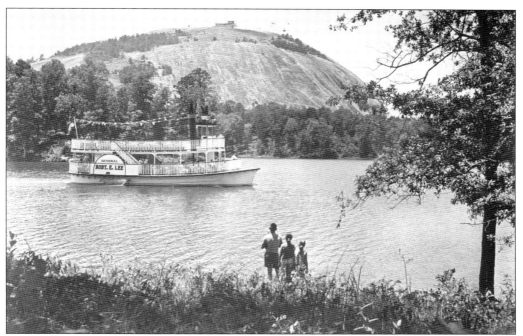

The *Robert E. Lee* paddles its way across the lake with Stone Mountain looming behind. We suppose you could say that the family on the shore is "waiting for the *Robert E. Lee*." (Linda Whittington collection.)

For the younger set, Stone Mountain Lake offered these seacraft, which were given the moniker "Molly Whale Boats." No, the author does not know where the name came from, either. (Author's collection.)

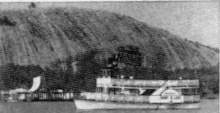

VISIT *Stone Mountain Marina*

● Ride The Showboats And Enjoy Mark Twainland ●

CANOES,
ELECTRIC
WHALE BOATS
AND
FISHING BOATS
FOR RENT

SOUVENIRS

FOOD & DRINKS

FREE PICNIC AREAS

● ON THE LAKE IN STONE MOUNTAIN MEMORIAL PARK ●
16 MILES NORTHEAST OF ATLANTA, GEORGIA

This advertisement pictures the new marina that had recently been added to the park. Yes, it is true: the shape of the building looks exactly like a Stuckey's candy store of the era. Exhaustive research has failed to turn up a single photograph of the "Mark Twainland" area this advertisement is plugging. (Author's collection.)

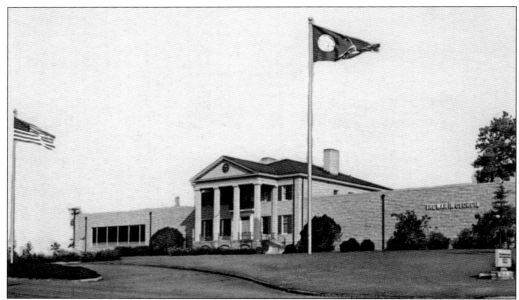

The Confederate Hall opened in 1963. Originally it contained a large 3-D relief map that illustrated Georgia's role in the Civil War through lighting and sound effects, quite similar to the better-remembered Confederama attraction in Chattanooga. (Author's collection.)

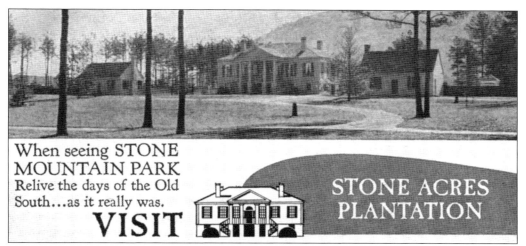

April 1963 saw the opening of Stone Mountain Park's latest feature, an antebellum plantation re-created on 18 acres. For the first few years it was known as Stone Acres, but this name was gradually allowed to fade away and be forgotten. (Author's collection.)

The plantation, as it was known in the post–Stone Acres era, consisted of genuine antebellum houses and structures that were purchased and moved intact to the park. (Linda Whittington collection.)

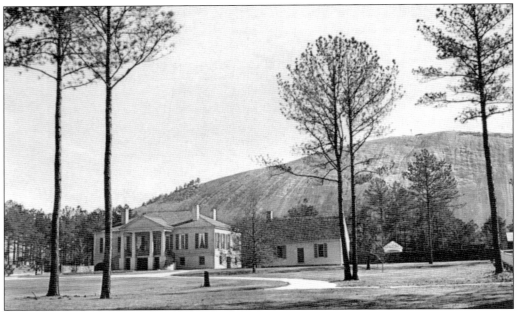

This was most photographers' favorite angle for shooting the main house of the plantation. Even though it was actually the back of the structure, it was the best way to capture the mansion and Stone Mountain in the same photograph. (Author's collection.)

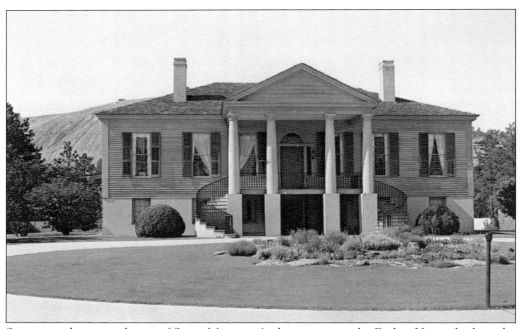

Serving as the manor house of Stone Mountain's plantation was the Dickey House, built in the late 1840s and originally located in southwestern Georgia. (Author's collection.)

Butterfly McQueen, who gained screen immortality as the squeaky-voiced maid Prissy in *Gone With the Wind*, served as the official hostess at the Stone Mountain plantation from 1963 to 1965. (Linda Whittington collection.)

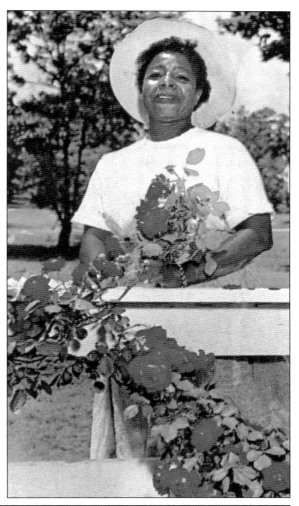

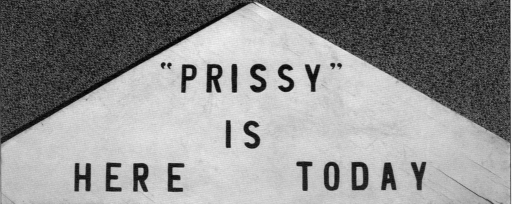

When McQueen was on duty, this sign was displayed at the plantation's entrance. Like the metal railroad sign seen earlier, it was discovered in the trash and was on the verge of being lost forever. (Linda Whittington collection.)

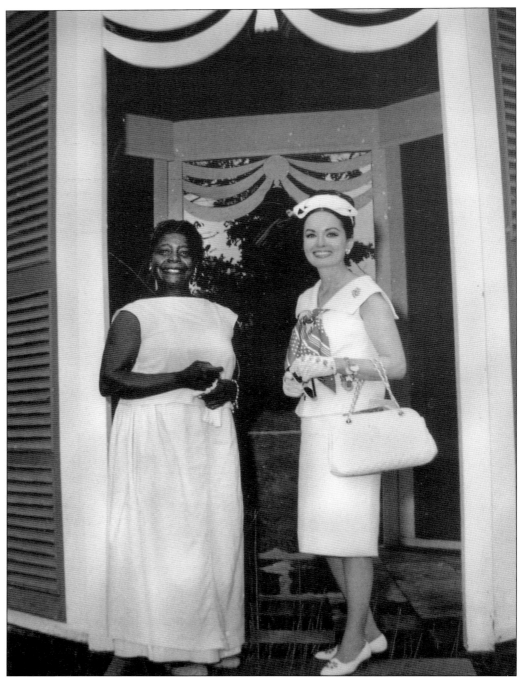

Ann Blyth (right) was one of many Hollywood celebrities who dropped in on their old coworker Butterfly McQueen at Stone Mountain. Blyth had a connection with another famous Southern attraction: in 1948, she filmed scenes for her movie *Mr. Peabody and the Mermaid* at Florida's Weeki Wachee Springs. (Linda Whittington collection.)

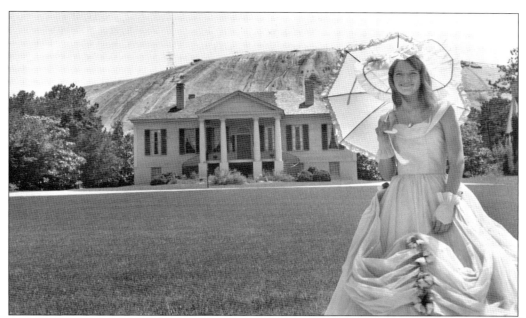

Although the plantation was still using Southern belles in its publicity in the 1970s, today it has sought to move beyond the romanticized *Gone With the Wind* image to present a more realistic view of pioneer life in Georgia. (Stone Mountain collection.)

...*the world's eighth wonder is now a wonderful vacationland*

Just 16 miles east of Atlanta, Georgia is Stone Mountain where the world's largest work of sculpture is being carved into the face of the world's largest granite monolith. See it by Swiss skylift, paddle-wheel steamboat, scenic railroad, from the terrace of the Civil War museum or walk to the Mountain's summit and look across the horizons of history. Here is Southern splendor—an authentic antebellum plantation, a luxurious Georgian-style Inn, gourmet food. For the camper, the fisherman, the horseback rider, the geologist, the archaeologist—there's everything wonderful for a visit or a vacation at Stone Mountain this year.

Just 20 minutes from Atlanta

STONE MOUNTAIN MEMORIAL PARK

Stone Mountain Park took out advertisements such as this one in national magazines during the mid-1960s, getting out the word about all the different sights tourists could see. (Author's collection.)

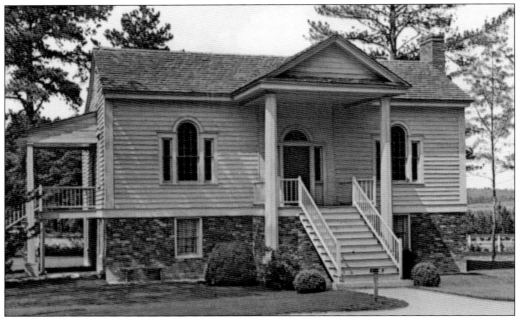

This 1845 building from Kingston, Georgia, was used as the "overseer's house" at Stone Mountain, but in actuality it was the main manor house in its original location—thus proving that not all plantation homes looked like Tara. (Author's collection.)

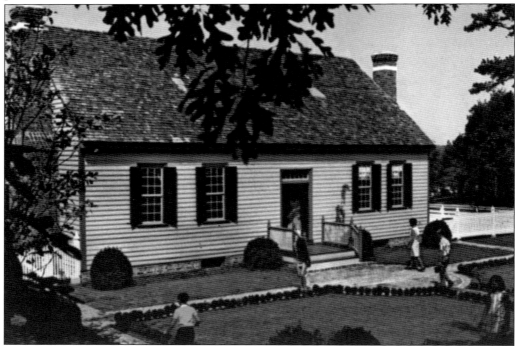

The Thornton House, constructed in 1791, was moved from Greene County, Georgia, to the Atlanta High Museum of Art in 1959. It made its way to Stone Mountain Park in 1967, where it was preserved as one of the state's few remaining 18th-century structures. (Author's collection.)

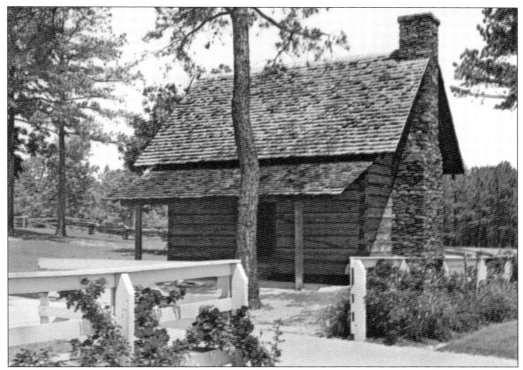

"Mammy's Cabin" was originally a doctor's office near Decatur, Georgia, built in 1826. The Stone Mountain plantation curators have recently begun reemphasizing its original function rather than using it as the home of a fictitious "Mammy." (Author's collection.)

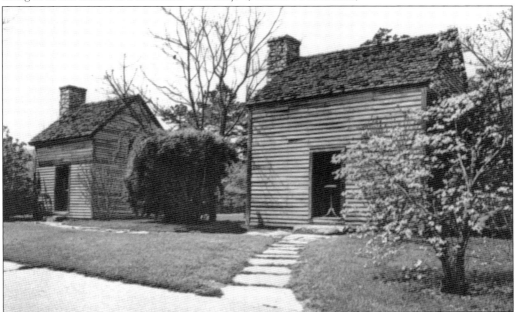

Stone Mountain Park acquired these two authentic slave cabins from a former plantation near Covington, Georgia. (Author's collection.)

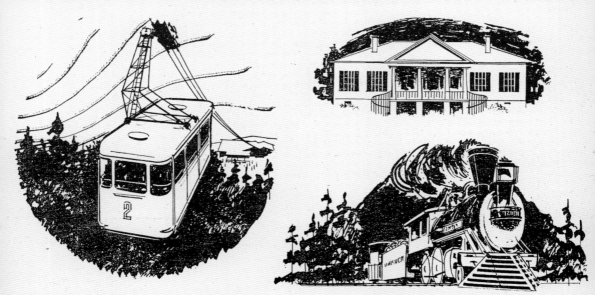

This advertisement ran in various tourism publications in May 1963, plugging the forthcoming advent of the marina (it did not say it looked like a Stuckey's), the *Robert E. Lee* side-wheeler, and the highly anticipated Stone Mountain Inn motel. (Author's collection.)

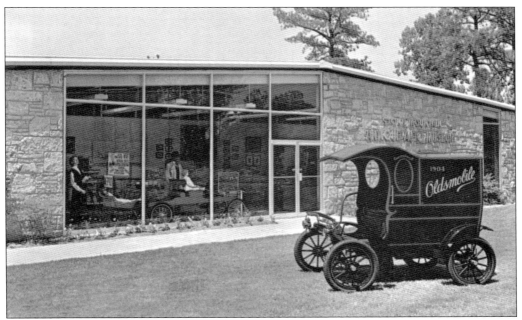

Another of Stone Mountain's many concessionaires, C. T. Protsman, displayed his amazing collection of vintage automobiles in the Antique Auto Museum. (Author's collection.)

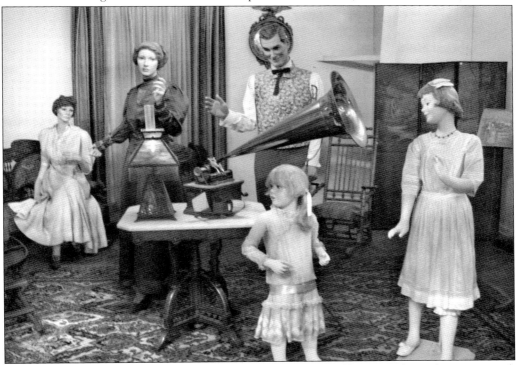

The Antique Auto Museum expanded its focus to encompass all matter of nostalgia in general. This diorama depicted a c. 1902 family listening to their gramophone. All that was missing was the family dog cocking his head to one side. (Author's collection.)

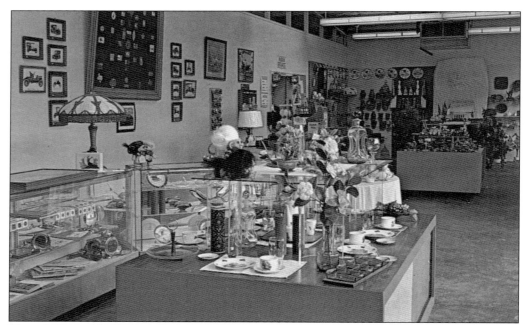

The gift shop at the Antique Auto Museum was different from most in that it sold actual antiques and relics in addition to mass-produced souvenirs. Ironically, the mass-produced souvenirs of that era are now antique store merchandise. (Author's collection.)

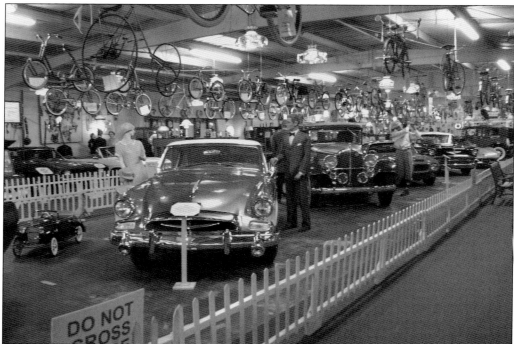

C. T. Protsman's collection of nostalgia knew no bounds, and all of it was attractively displayed in his museum. Besides automobiles, he had an unbelievable number of coin-operated music machines and other penny arcade relics. (Author's collection.)

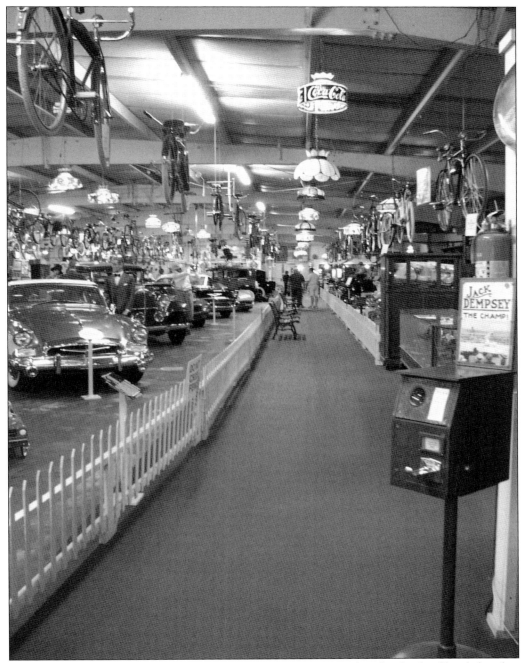

Protsman's son continued running the Antique Auto Museum after the death of his father, but after the Christmas season of 2008, he auctioned off the priceless contents and closed the facility for good. (Author's collection.)

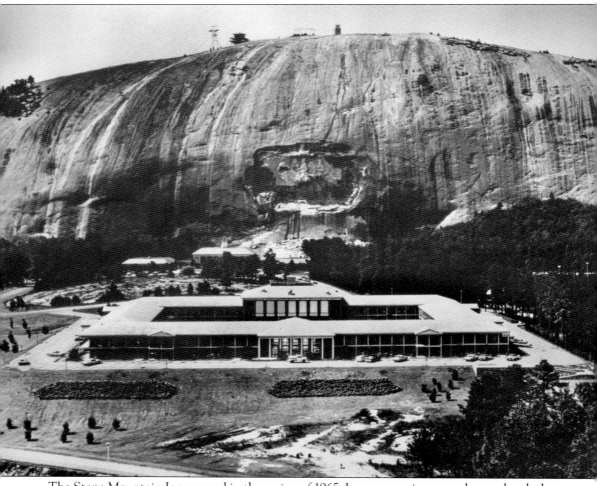

The Stone Mountain Inn opened in the spring of 1965. Its construction caused many headaches for the Stone Mountain Memorial Association, not the least of which was that all but 10 of the double rooms were equipped with European bidets, which many Americans thought bordered on the pornographic—or at the very least could be mistaken for drinking fountains. The hotel survived its initial rocky path to become a park institution. (Linda Whittington collection.)

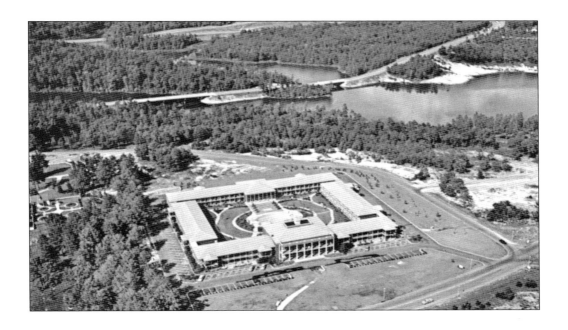

Despite its shaky beginnings, the Stone Mountain Inn was comparable to most chain motels of its era, even to the swimming pool that was a necessary fixture of any roadside lodging in the 1960s. The main difference is that this one was inside a state park instead of rubbing shoulders with Holiday Inn and Howard Johnson's. (Both Author's collection.)

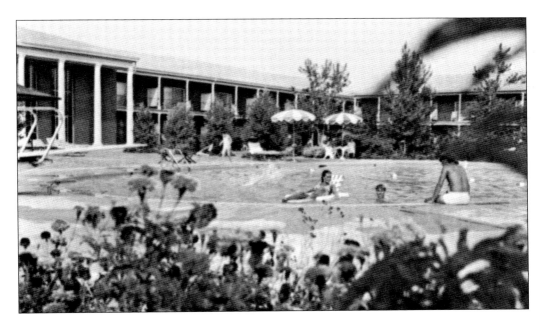

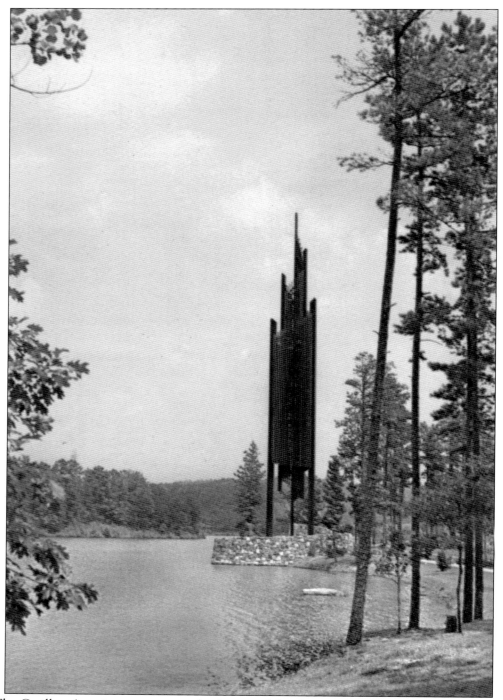

The Carillon Americana was a popular feature of the Coca-Cola pavilion at the 1964–1965 New York World's Fair. After the fair's end, the Atlanta-based soft drink company donated the musical instrument to Stone Mountain Park, where it was set up next to the lake. (Linda Whittington collection.)

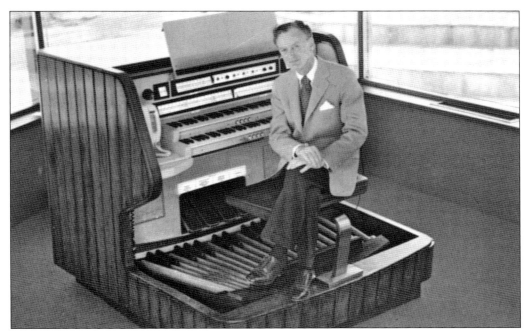
Musician Herbie Koch was the longtime performer on Stone Mountain's carillon. He gave daily concerts during the summer tourist season and recorded several albums of his music. (Author's collection.)

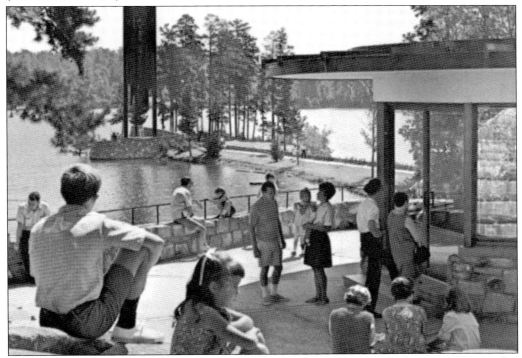
The audiences for Herbie Koch's carillon concerts sat in an outdoor amphitheater and listened to him perform hymns, classical music, and traditional Southern tunes. (Author's collection.)

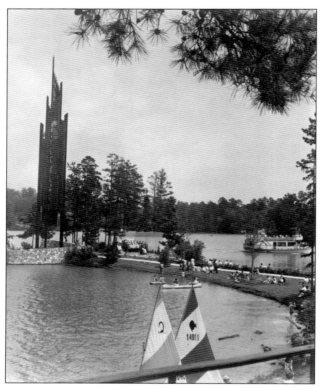

The original caption on this press release photograph reads, "Stone Mountain Park's marina offers a variety of rental vessels for visitors. Sailboats (foreground), canoes, fishing boats and children's whaleboats are available. The paddle-wheel cruise boat *Robert E. Lee* (right) cruises 433-acre Stone Mountain Lake on the hour. Daily concerts are presented on the world's biggest carillon (center)." (Linda Whittington collection.)

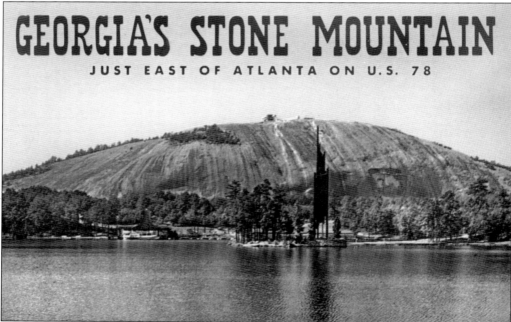

When U.S. Highway 78 was routed a mile north of its original location so the old two-lane road could be buried under Stone Mountain Lake, the highway department made the new route into a controlled-access freeway with its own exit to the park. (Author's collection.)

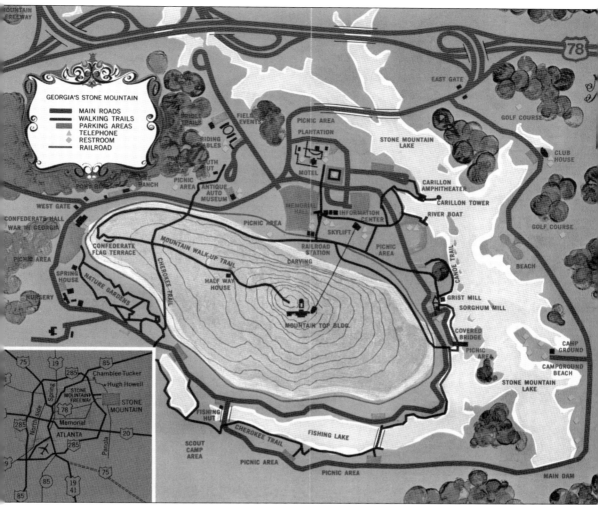

By the late 1960s, Stone Mountain Park was literally packed with things to do and see. This map shows where all the different attractions lay, but note that the carving, which was the reason for the park's existence, is barely indicated at all. That was soon to change. (Author's collection.)

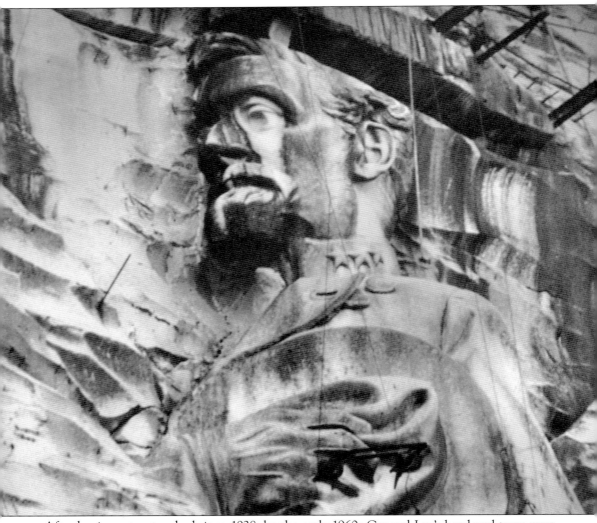
After having sat untouched since 1928, by the early 1960s General Lee's head and torso were streaked and stained, and the wooden platform and scaffolding had mostly rotted away. With the rest of the park drawing large numbers of visitors, the Stone Mountain Memorial Association decided the time had come to do something about completing the project that had already had so many false starts and bitter ends. (Stone Mountain collection.)

In January 1964, the memorial association contracted with sculptor Walker Hancock of New York to complete the Stone Mountain carving according to the design Augustus Lukeman had begun. (Stone Mountain collection.)

Although Hancock was contractually obligated not to radically alter the Lukeman plans, he was able to make a few improvements here and there. In this shot, he is seen lowering the head of Lee's horse so as not to obscure Jefferson Davis and his steed as much. (Stone Mountain collection.)

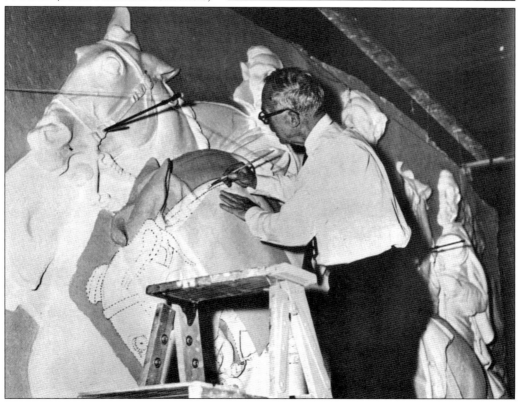

This postcard view was made just as work was beginning to get underway once more. Note that the outlines of Davis and the horses are barely discernable, while Stonewall Jackson is not much more than a flat spot in the stone. (Author's collection.)

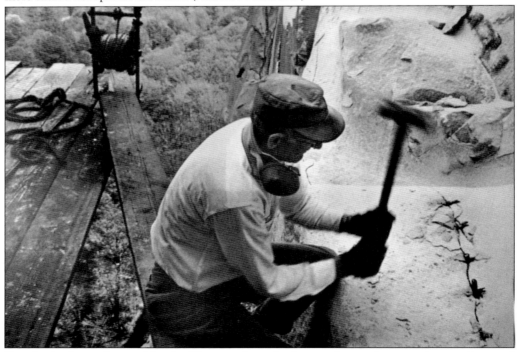

Gravity had not changed in the 36 years since the last work was done on the carving, and the workers still had to perch precariously on narrow boards to do the close-up work. (Stone Mountain collection.)

At least tools had improved since 1928; here Roy Faulkner, the foreman of the new carving crew, is using a thermo-jet torch to refine the features of Lee's face. (Stone Mountain collection.)

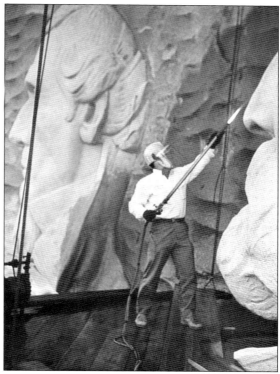

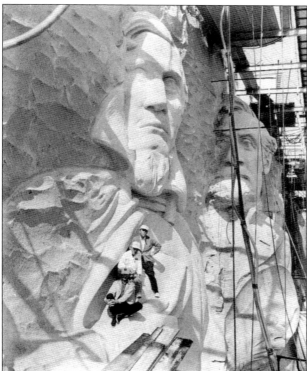

Stone Mountain Park has preserved this May 1966 photograph as a reminder of tragedy. The carver in the foreground, Howard Williams, was killed three months after posing for this shot when his scaffold gave way and he fell 400 feet to the ground below. (Stone Mountain collection.)

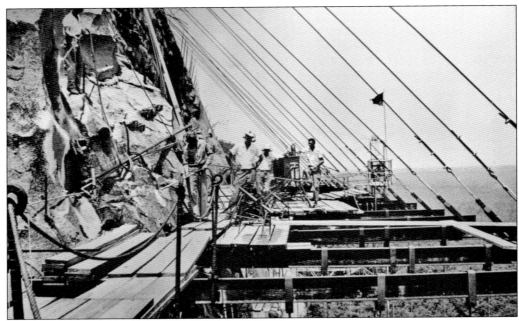

After Williams's untimely demise, all but two of the other workers quit their jobs, forcing Roy Faulkner to hire a new crew. But working on a sheer cliff 40 stories above the ground was not a safe job no matter how it was carved up. (Stone Mountain collection.)

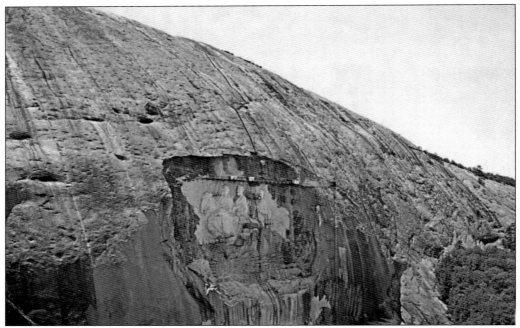

This distant view shows how visitors to Stone Mountain Park viewed the progress on the carving. From a distance, the many workmen looked like a colony of ants swarming across the mountain's face. (Author's collection.)

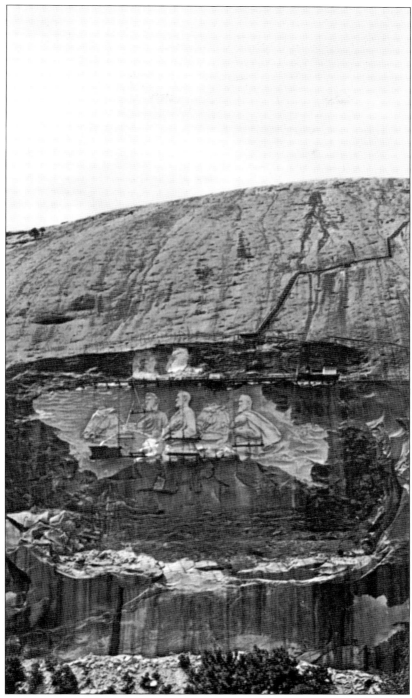

By the time of this photograph, Stonewall Jackson had made his long-delayed debut on the side of Stone Mountain. However, that is not the most interesting thing about it. Note that from this angle, after so many years, the scar of Borglum's original Lee head was still visible above the new Lee. (Author's collection.)

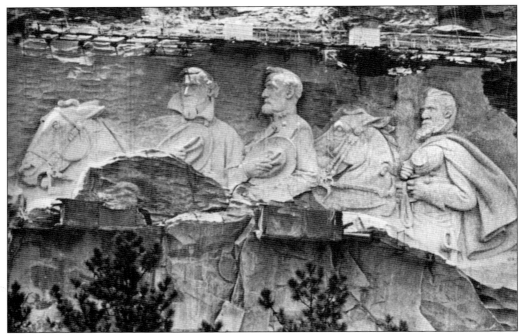
This first attempt at carving Stonewall Jackson's head had to be scrapped and done a second time due to its ugliness. Historian David Freeman remarked that Jackson's nose looked like it belonged on Jimmy Durante. (Stone Mountain collection.)

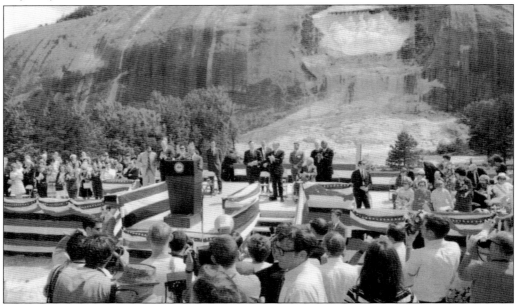
After all the arguing, fitful stops and starts, and loss of life, Vice Pres. Spiro Agnew finally dedicated the memorial carving on May 9, 1970. Considering that some people still thought of the carving as a Ku Klux Klan project, it was ironic that the Klan boycotted the ceremony because one of Atlanta's most prominent black ministers was asked to give the invocation. (Linda Whittington collection.)

On September 19, 1970, the U.S. Postal Service released a commemorative stamp picturing the Stone Mountain carving. A special branch office was set up atop the mountain to issue the postmark. (Both Linda Whittington collection.)

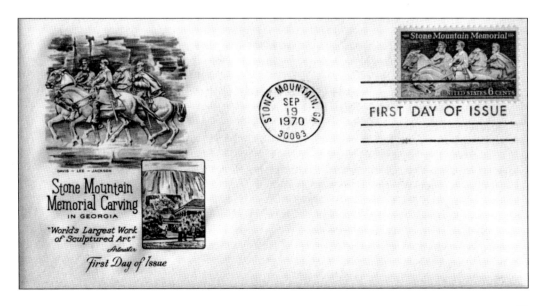

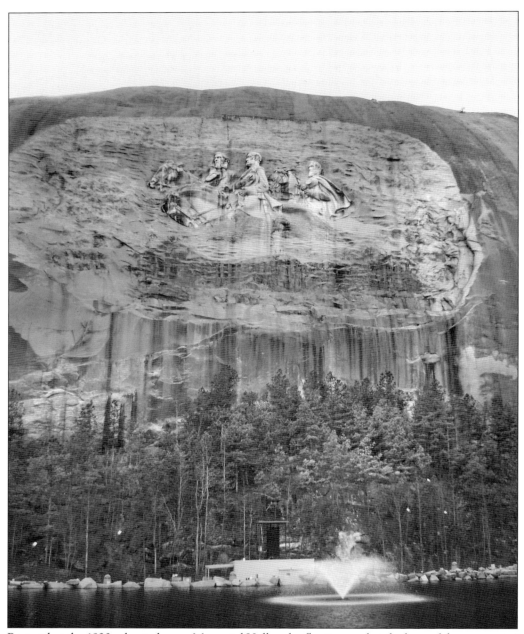
Remember the 1920s plan to have a Memorial Hall and reflecting pool at the base of the mountain? That never happened not only because of lack of funds, but also because the workers found that a large outcropping prevented the mountain from continuing straight into the ground. This larger reflection pool and fountain were put into place to help fill in what would have been a major empty spot. (Author's collection.)

This brochure was published while work on the carving was still in progress. There may even have still been hope that the horses' legs and hooves would eventually be added, but that was never to happen. (Author's collection.)

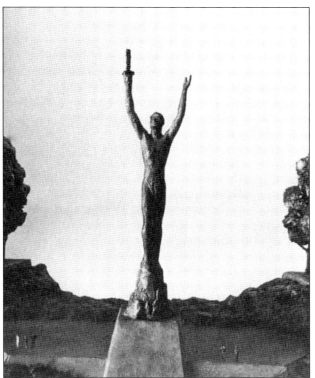

When Walker Hancock was enlisted to finish the carving, he was also charged with designing a true Confederate Memorial to carry on the project's original purpose. This rough rendition of a statue was Hancock's first attempt at coming up with a concept for his next phase. (Stone Mountain collection.)

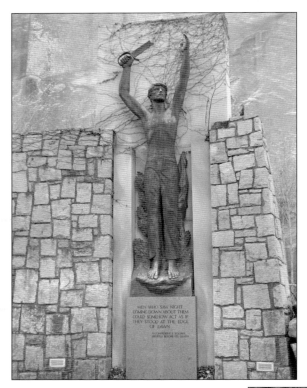

The Confederate Memorial Plaza was finally completed and dedicated on April 23, 1978. It featured two statues executed by Hancock, one of which was this 17-foot-tall version of his original concept, given the title *Valor*. (Author's collection.)

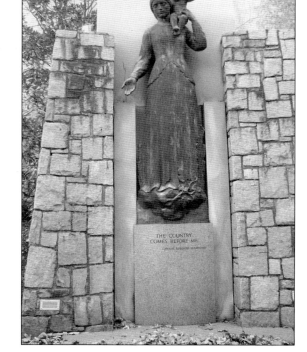

The other half of the Confederate Memorial Plaza is dominated by Hancock's 14-foot-tall *Sacrifice*, representing the numerous families torn apart by the tragic conflict. (Author's collection.)

Four
Taking the Mountain Home with You

A huge part of any tourist attraction, whether it be in the sunny South, dignified North, stately East, or let-it-all-hang-out West, was the souvenir shop. Just because Stone Mountain was a state park did not mean that it could not be commercialized and images of its attractions plastered onto every conceivable type of doodad, whatnot, doohickey, and other items that defied logical naming.

In this section, take a quick look at the many different types of Stone Mountain souvenirs. A word about trying to trace this type of history: the collecting and preserving of tourism souvenirs, especially the Southern ones, is a relatively new craze. When these items were produced, there was never any thought that they were going to be deemed worthy of any sort of historical preservation. This meant that not only were they manufactured in the least expensive (and thus, least durable) materials available, but more often than not there is no evidence to help determine just when they were made or marketed in the first place. With rare exceptions, no copyright dates appear on any of them, and it sometimes takes a keen eye to spot details that help place an item into even a roughly accurate time period.

Even more flexible are the values assigned to such items today. One can visit a local thrift store and find Stone Mountain souvenirs dating back to the early 1960s for 25¢, whereas the same item might turn up in an antique store—particularly in the Atlanta area—for $10 or $20. Collecting souvenirs is not something one should do as a financial investment. Instead, realize that an item is worth whatever someone else is willing to pay for it. It is best to simply enjoy them for their original purpose of commemorating an attraction, whether inspiring or tacky, and helping spread the word to potential future tourists. Look closely at some of the items presented here; some readers may still have some in their own attic or storage room.

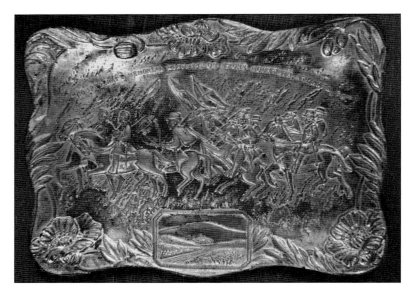

One way to at least guesstimate the age of a Stone Mountain souvenir is by how many figures are represented in the carving. This metal ashtray must have been one of the earliest pieces since it contains the Confederate flag bearers and numerous other soldiers. (Author's collection.)

This postcard folder from the 1920s took a bit of artistic license not only with the nonexistent carving, but also with Stone Mountain looming over the Atlanta skyline, which was actually 16 miles away. (Author's collection.)

A different postcard folder used one of the plaster models of the proposed carving to represent the finished artwork. Inside, a caption boasted that the completed carving would be 138 feet tall and a quarter of a mile long. (Author's collection.)

These miniature cup-and-saucer sets were standard features of nearly any tourist attraction for decades. Whereas most later cup-and-saucer souvenirs have the image baked onto the ceramic, the Stone Mountain images on this one are glued-on paper decals. (Author's collection.)

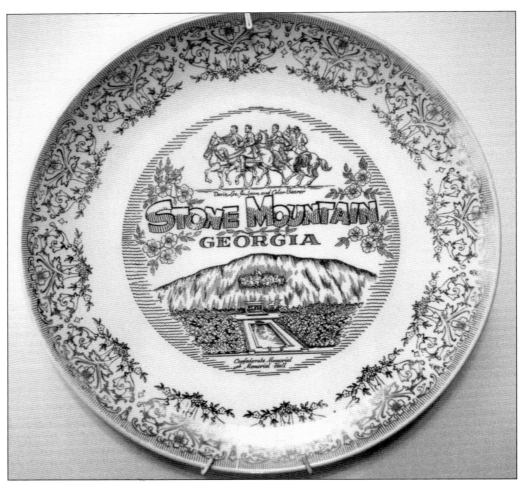

The company that manufactured this souvenir plate mixed iconography from several different sources; the top drawing depicts the three main figures and one additional soldier, while the bottom drawing optimistically continues to feature the long procession and the Memorial Hall and pool at the base. (Author's collection.)

Souvenir felt hats were a trend that did not last as long as some others, such as cup-and-saucer sets, plates, and felt pennants. This example still sported a four-figure design for the carving. (Linda Whittington collection.)

This children's jigsaw puzzle must have been one of the first souvenirs produced after the state purchased Stone Mountain. The lakeshore was still looking rather primitive at the time this photograph was taken. (Linda Whittington collection.)

As mentioned earlier, Stone Mountain Park's Game Ranch was one of the least publicized attractions, but it did manage to make it onto a souvenir plate all by itself, as well as a set of salt-and-pepper shakers. (Both Linda Whittington collection.)

Earlier it was written that the reader would see the concept art for the Stone Mountain Scenic Railroad turning up again. Here it is re-created in bas-relief form for a souvenir plate—or actually, it is more like a bowl. This particular item still has its "Stone Mountain R. R." price sticker on the back, revealing that it retailed for $1.69 when new. (Author's collection.)

This style of bas-relief plate was obviously produced much later than the example in the previous photograph, especially since it shows the carving as it actually ended up—that is, no legs on the horses. The locomotive, riverboat, and some flowers make this one an unusually colorful artifact. (Linda Whittington collection.)

After the railroad, the skylift probably generated more souvenirs than any other sight in the park. This ashtray did a good job of picturing the spaced-out entrance building. (Author's collection.)

This magnifying glass was one of the items the author's parents bought for him on their first visit to Stone Mountain in 1967. Note that the artist chose to have the skylift's roof striped like a red-and-white circus tent. (Author's collection.)

This was most likely the earliest album recorded by Herbie Koch on the Carillon Americana. The first side consisted of classical and folk tunes, while the second side presented Southern standards, including the *Gone With the Wind* theme, "My Old Kentucky Home," and "Dixie." (Author's collection.)

Another of Herbie Koch's albums of carillon music featured selections ranging from "Let There be Peace on Earth" to "America the Beautiful" and "When They Ring the Golden Bells." This particular album was released to tie-in with the 1970 dedication of the memorial carving. (Author's collection.)

Obviously, Herbie Koch was not going to pass up an opportunity for a Christmas album, and as one might expect, this one featured the carillon ringing out a number of hymns and carols. (Author's collection.)

Somewhat surprisingly, Georgia's Decatur Federal Savings and Loan cosponsored the Stone Mountain Christmas album. How long has it been since a bank used a cute mascot character such as Decatur Federal's "Katy"? (Author's collection.)

Any tourist who has gotten out of his or her backyard knows that felt pennants were the staple of any souvenir shop. These two were obviously produced at about the same time, but each had its own selection of park scenes. Take a good look at the example above: there is that Stone Mountain Scenic Railroad concept art again. Each pennant was printed in loud fluorescent colors that fairly leapt off the felt. (Both Author's collection.)

Remember the Mold-A-Rama machines? A coin was inserted and the machine would pour melted wax into a mold, bake it, and drop out a hollow wax souvenir of a visit to the park. Stone Mountain's mold reused the Stone Mountain Scenic Railroad concept art for the umpteenth time. (www.moldaramaville.com.)

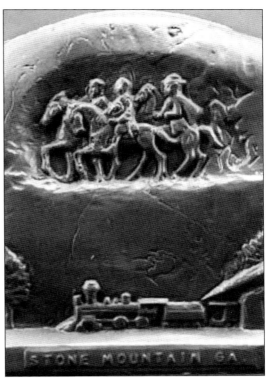

This decorative wall hanging may border on the abstract more than any other Stone Mountain souvenir. The carving is barely indicated, but if this could be seen in color, one would marvel at how purple the mountain is. (Author's collection.)

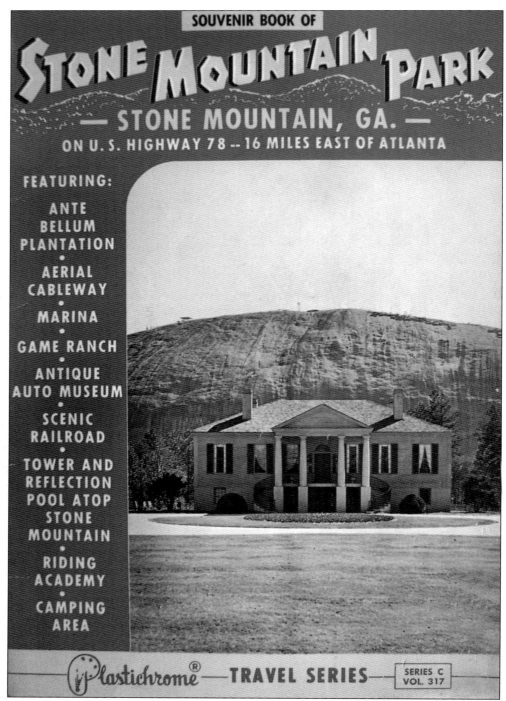

Souvenir booklets were a popular way to collect together many of the views that were also sold individually as postcards. This is one of the finest examples of all, a typically lavish production by the Plastichrome company of Boston. Somewhat unusually, the photographer positioned himself so the plantation manor house obscured the unfinished carving. (Stone Mountain collection.)

Another souvenir booklet focused almost entirely on the plantation and gave short shrift to the other park attractions. It too was produced by Plastichrome of Boston and, as seen on the price sticker, originally sold for a buck and a half. (Author's collection.)

This, ladies and gentlemen and boys and girls, may have been Stone Mountain Park's masterpiece when it came to unique souvenirs. Granted, a punch-out cardboard train might not have been as durable as the electric model that could be found under the Christmas tree, but the artwork

on the front was enough to justify the purchase price—even if it did presume that the carving, when finished, would include feet and legs. (Author's collection.)

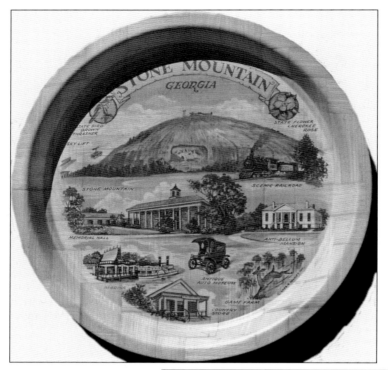

The Carrib Novelty Company of Dade City, Florida, made these bamboo trays for countless tourist attractions in the South and elsewhere, and every one of them had the same quality artwork as these delicate renditions of Stone Mountain's principal sights. (Linda Whittington collection.)

Sometimes the souvenir companies either misunderstood the information they were given or simply made it up as they went along. This coffee cup was a fine item, but somehow the antebellum plantation house was mislabeled as a "colonial mansion." (Author's collection.)

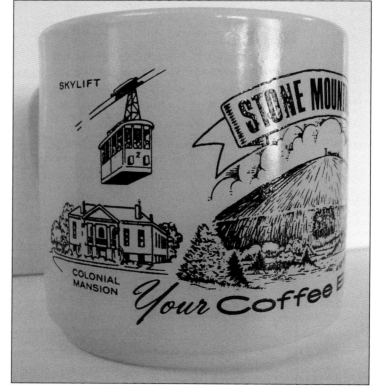

Something Stone Mountain's gift shops sold that could not be found anywhere else were actual chunks of the granite blasted off the mountain each day during the carving process. As can be seen from the fading crayon markings by the author's mother, this was purchased on the family's January 1968 visit. (Author's collection.)

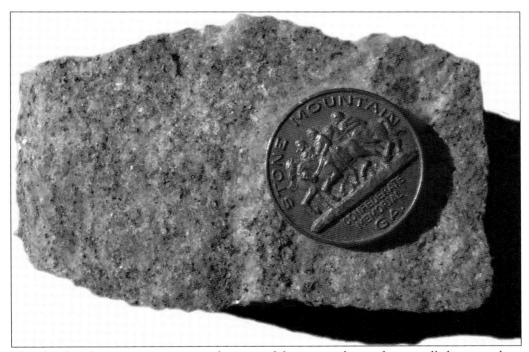

The chunks of granite came in sizes that ranged from several pounds to small slivers, such as this one adorned with a medallion. Obviously, the supply was necessarily a finite amount, and even though the pieces have not been sold for years, the park reports that people who remember buying them in the past still ask for them. (Linda Whittington collection.)

This 1960s postcard might be an updated (and corrected) version of the early one seen back on page 94. Since the mountain and the Atlanta skyline could not reasonably appear in the same shot, this "split screen" approach was the logical solution. (Linda Whittington collection.)

This foldout postcard packet was first produced in 1962. The contents would later be updated, but the set remained on sale for most of the rest of that decade. (Author's collection.)

This later felt pennant was about a third of the size of the ones seen earlier, but just like those, it was printed in flaming Day-Glo colors. It sold for 69¢ when new. (Author's collection.)

For the souvenir collector who already has everything, what about an unused annual parking permit from the year the carving was finally completed and dedicated? There are probably not many of these around, since using them would have meant their destruction. (Author's collection.)

By the time of this 1989 brochure, several changes had taken place in the park. The original Stone Mountain Scenic Railroad depot had been demolished and replaced with a more modern structure, the *Robert E. Lee* paddle wheeler had been replaced by the *Scarlett O'Hara* (well, fiddle dee dee!), and the summer months brought a laser light show projected onto the north face of the mountain, incorporating the carving into the performance. (Author's collection.)

Five

Stone Mountain at the Crossroads of Life

After the dedication of the completed carving in 1970 and Walker Hancock's final work on the Confederate Memorial in 1978, Stone Mountain State Park continued to rock along much as it always had. It remained one of Georgia's most-visited tourist attractions, but other than expanding facilities for camping, golf, and other healthy outdoor activities, everything seemed to be running as smoothly as the slick granite surface of the mountain.

The world's attention was focused on the park in 1996 when it became the site of some of the events of that year's Atlanta Olympic Games. This new visibility caused the state to make some sweeping changes in the already-established park, including a new museum documenting its history and a facelift for the skylift. Once the Olympic athletes had departed, though, Georgia began to think seriously about whether it wanted to continue being responsible for such an expensive piece of property.

With privatization all the rage, in 1997 the state announced that it was seeking a company to take over the commercial operation of the park. People screamed and cried that Stone Mountain's integrity was at stake. An editorial in the *Atlanta Constitution* warned: "Though the bidding companies intend only to renovate existing park facilities in the first few years of the contract, their main thrust eventually will be development of new attractions in the already overburdened park. At that point, the park's status as a state-owned facility of historic importance will collide with private industry's intention to indulge in 'idealized reality' and 'edutainment.'"

The bidder that ended up with Stone Mountain Park was Herschend Entertainment, the family-owned company responsible for Silver Dollar City in Branson, Missouri, and its Tennessee kissin' cousin, Pigeon Forge's Dollywood. (The losing bidder was Delaware North Park Services, whose very name had two strikes against it for operating a Confederate memorial.) To date, the Herschends have poured several million dollars into Stone Mountain additions and upgrades, but the centerpiece of the whole project—those legless Confederate icons Lee, Davis, and Jackson, and their equally legless equestrian mounts—continues to peer down at visitors as it has for decades and theoretically will do so for a few hundred years into the future.

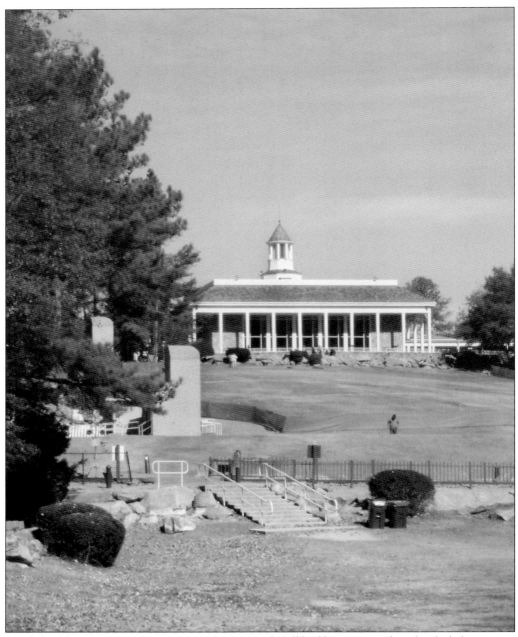
Until the Olympics came to town in 1996, Memorial Hall had been primarily a glorified observation platform for the carving. Realizing that more attention than ever before would be focused on the park, the administrators gave the stately building a makeover and converted it into a true museum of the area's history. (Author's collection.)

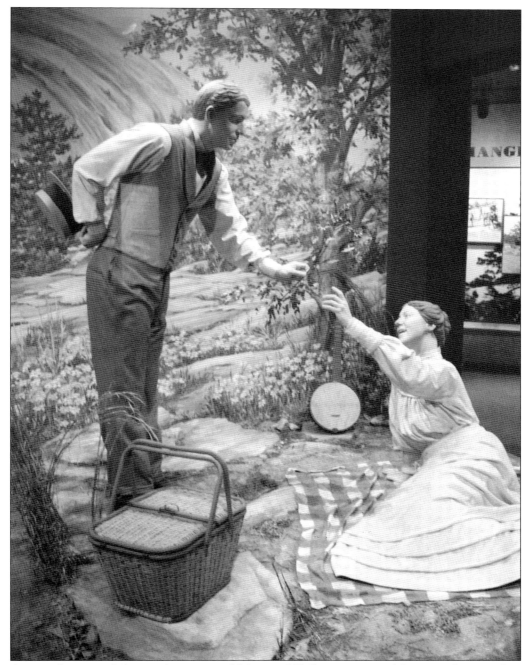

Among the new exhibits in the renovated Memorial Hall was a series of dioramas depicting key moments in the mountain's past. This one was supposed to represent a couple having a romantic picnic in the mountain's shadow in the early days, but it looks as if the lady is saying, "I've fallen, and I can't get up." (Author's collection.)

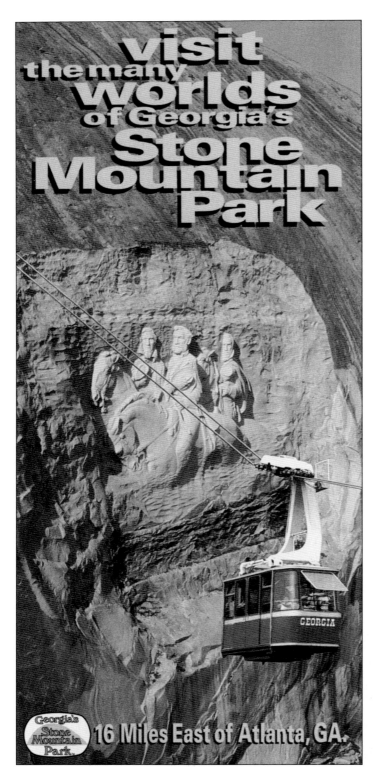

This 1994 brochure was one of the last designs produced while the park was still being run by the State of Georgia. (Author's collection.)

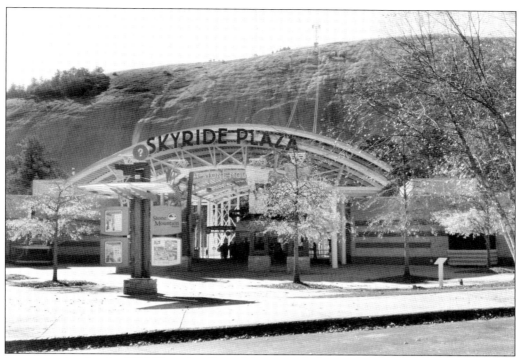

In preparation for the 1996 Olympics, Stone Mountain Park completely rebuilt and rerouted the 1962 skylift. Instead of the old space age–influenced building, this hangar-type structure and streamlined cable cars awaited visitors of the late 1990s. (Author's collection.)

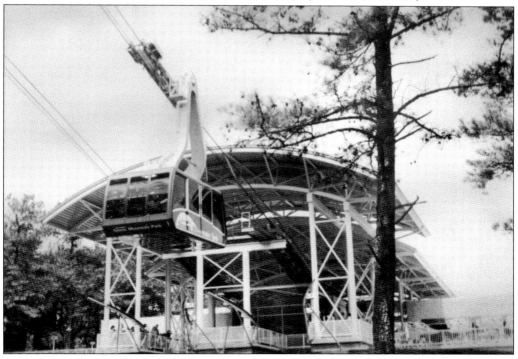

This book, published by Mercer University Press in Macon, Georgia, just prior to the privatization of the park, is the most complete account available of all the travail involved with the memorial carving during the Borglum, Lukeman, and Hancock eras—not to mention the periods of inactivity in between. (Author's collection.)

Jack and Pete Herschend and their family had become legends in the tourism world by virtue of their Silver Dollar City park near Branson, Missouri. They later opened a Silver Dollar City branch at Pigeon Forge, Tennessee, which is now known as Dollywood. (Author's collection.)

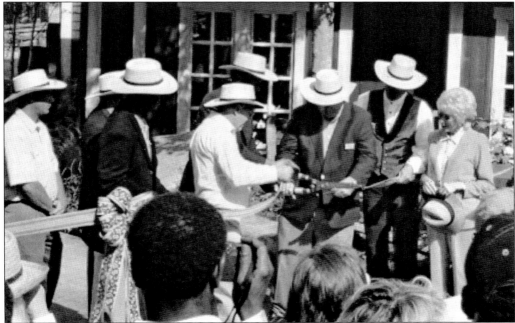

After Herschend Entertainment acquired Stone Mountain Park in 1997, the company set about bringing it in line with its other properties by constructing an adjacent community named Crossroads. Here members of the Herschend family participate in the ribbon-cutting ceremony in 2002. (Stone Mountain collection.)

Crossroads was the Atlanta equivalent to the famed handicraft demonstrations and gift shops that had been so successful at Silver Dollar City and Dollywood. It was meant to suggest what the community of Stone Mountain was like before the advent of the Civil War. (Author's collection.)

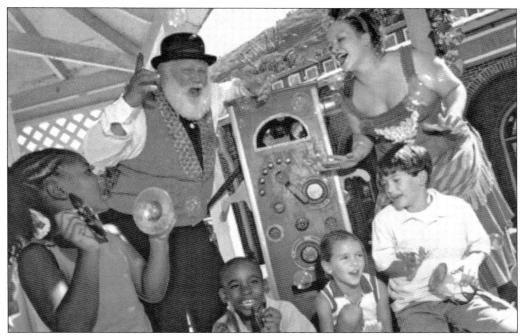

Some of the more successful characters and skits from Silver Dollar City were imported to Stone Mountain Park. During the third year Crossroads was in operation, Scott Rousseau yukked it up with kids as the energetic "Rainmaker." (Stone Mountain collection.)

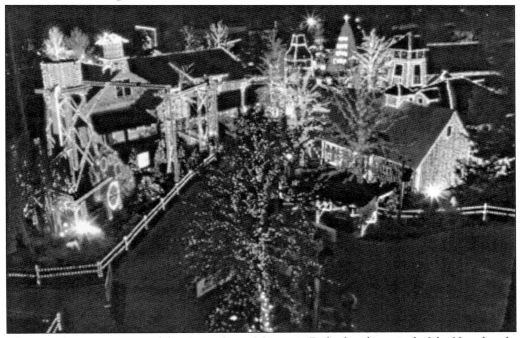

Christmas became a major celebration at Stone Mountain Park after the arrival of the Herschends. The entire Crossroads section was decked with enough holly and lights to make even Scrooge sing "fa la la." (Stone Mountain collection.)

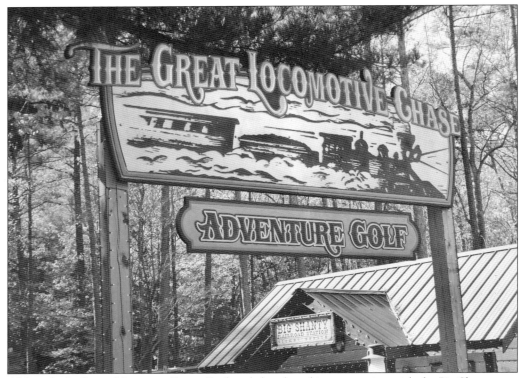

Although the Stone Mountain Scenic Railroad abandoned its connection with the Big Shanty–to–Ringgold "Great Locomotive Chase," that epic event in Georgia history lives on as the theme for the park's miniature golf course, completed in 2007. (Author's collection.)

During the holiday season each year, the television/radio tower next to the skylift on Stone Mountain's summit is converted into what must be one of the world's largest lit Christmas trees. (Author's collection.)

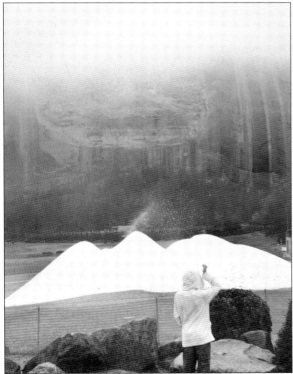

Another Yuletide innovation of recent years is "Snow Mountain," where machines coat the entire slope from Memorial Hall to the base of the mountain with genuine snow, turning it into a sledding area normally unseen in the sunny Southland. (Author's collection.)

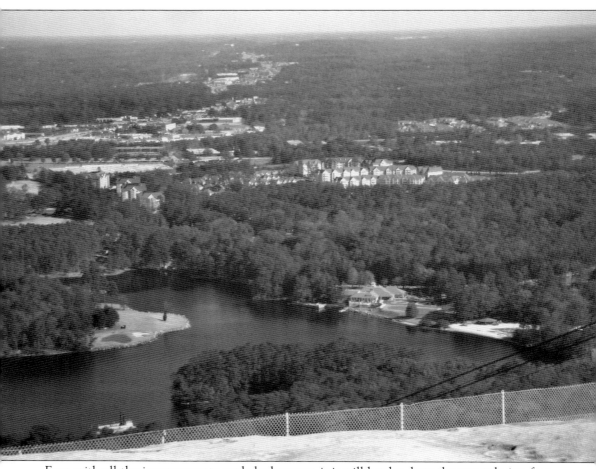

Even with all the improvements made by humans, it is still hard to beat the natural view from the top of Stone Mountain. The lake created by burying much of old U.S. 78 in 1961 is still a center of activity; in the distance can be seen much of the commercial development that now lines present-day U.S. 78. (Author's collection.)

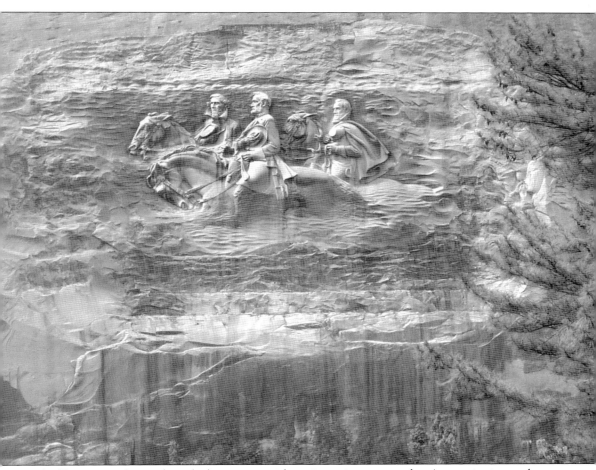
And here it is—the much worked over memorial carving as it appears today. At certain times, when the angle of the sun is just right, the smoothed-over scar of Borglum's original Lee head can still be seen directly over Lukeman's figure of Lee, as evidenced by this shot. (Author's collection.)

Discover Thousands of Local History Books
Featuring Millions of Vintage Images

Arcadia Publishing, the leading local history publisher in the United States, is committed to making history accessible and meaningful through publishing books that celebrate and preserve the heritage of America's people and places.

Find more books like this at
www.arcadiapublishing.com

Search for your hometown history, your old stomping grounds, and even your favorite sports team.

Consistent with our mission to preserve history on a local level, this book was printed in South Carolina on American-made paper and manufactured entirely in the United States. Products carrying the accredited Forest Stewardship Council (FSC) label are printed on 100 percent FSC-certified paper.